START
PAINTING
NOW

First published 2022 by Bluebird
an imprint of Pan Macmillan
The Smithson, 6 Briset Street, London EC1M 5NR
EU representative: Macmillan Publishers Ireland Ltd, 1st Floor,
The Liffey Trust Centre, 117–126 Sheriff Street Upper,
Dublin 1, D01 YC43
Associated companies throughout the world
www.panmacmillan.com

ISBN 978-1-5290-8493-1

1 3 5 7 9 8 6 4 2

A CIP catalogue record for this book is available from the British Library.

Printed and bound in Italy.

Publisher Carole Tonkinson
Project Editor Katy Denny
Managing Editor Martha Burley
Assistant Editor Zainab Dawood
Designer Izzi Balfour
Senior Production Controller Sarah Badhan

EMILY POWELL
SARAH MOORE

START
PAINTING
NOW

Discover your artistic potential

bluebird
books for life

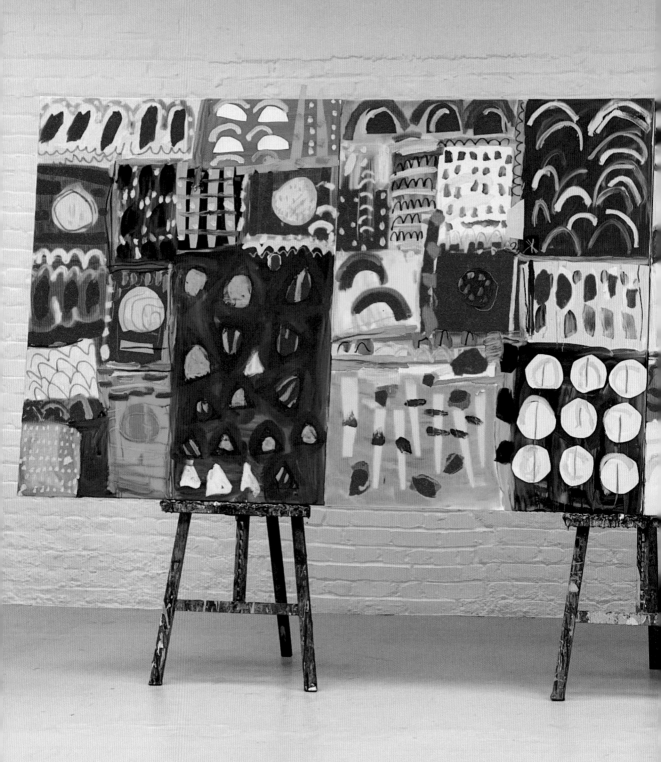

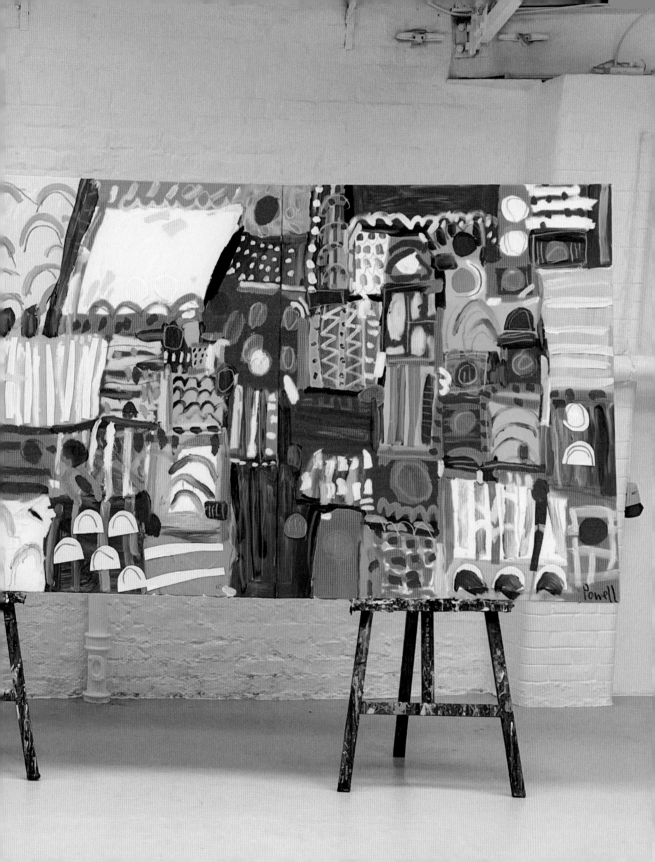

This book is dedicated to our mum and dad who still inspire us every day.

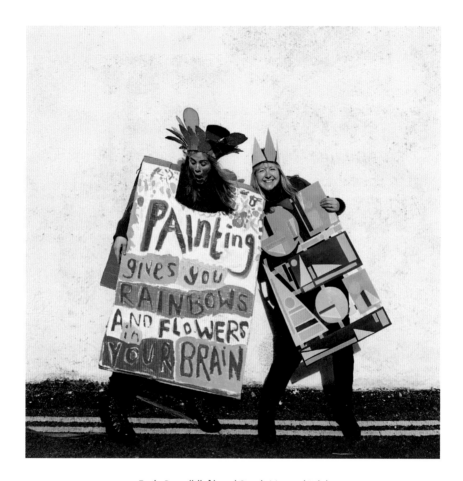

Emily Powell (left) and Sarah Moore (right)

Contents

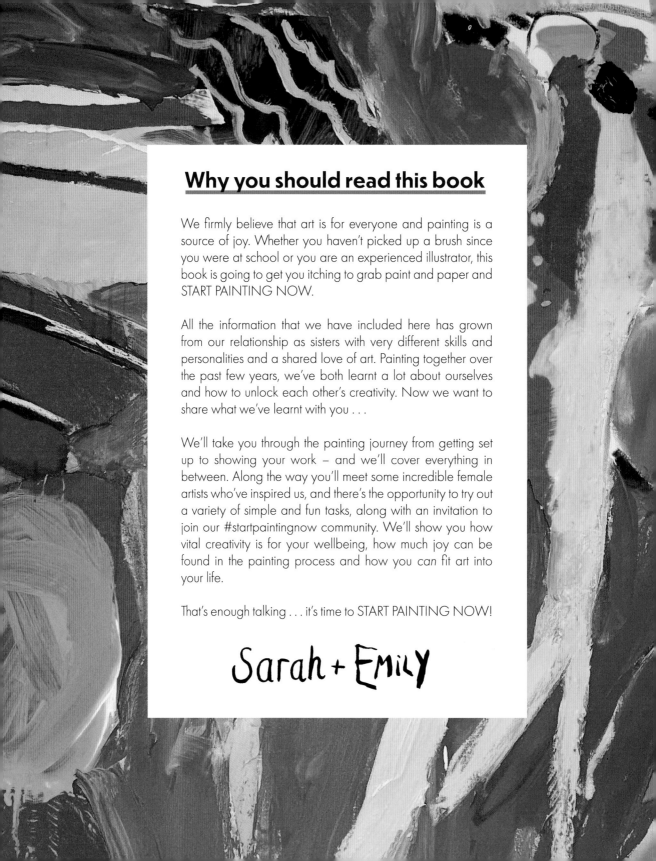

Why you should read this book

We firmly believe that art is for everyone and painting is a source of joy. Whether you haven't picked up a brush since you were at school or you are an experienced illustrator, this book is going to get you itching to grab paint and paper and START PAINTING NOW.

All the information that we have included here has grown from our relationship as sisters with very different skills and personalities and a shared love of art. Painting together over the past few years, we've both learnt a lot about ourselves and how to unlock each other's creativity. Now we want to share what we've learnt with you . . .

We'll take you through the painting journey from getting set up to showing your work – and we'll cover everything in between. Along the way you'll meet some incredible female artists who've inspired us, and there's the opportunity to try out a variety of simple and fun tasks, along with an invitation to join our #startpaintingnow community. We'll show you how vital creativity is for your wellbeing, how much joy can be found in the painting process and how you *can* fit art into your life.

That's enough talking . . . it's time to START PAINTING NOW!

Sarah + Emily

Meet Emily and Sarah

We grew up just outside Liverpool, in the northwest of England, with parents who were both teachers. Sarah was born first, followed two years later by our middle sister Naomi, then another two years later by Emily. All three of us loved art as we grew up and only now do we realise how lucky we were to have had a childhood filled with opportunities to see and make artworks. We would often be found around the kitchen table with Mum after school, cutting and sticking, drawing and painting. Our dad had appropriated the garage for use as his (very chilly) creative space, where he enjoyed painting watercolours in his spare time. We used to visit him there and do projects such as building a Viking village. Dad sadly died from cancer when he was only forty-four and when Sarah was eleven and Emily seven years old. This had a profound impact on our childhoods and our future personalities. Both of us have worked hard, hoping to make him proud; Emily as an artist, fulfilling his passion and dreams, and Sarah as a doctor and researcher, trying to help diagnose cancer earlier so other families don't have to go through the same heartache as we did. In a broader sense, we learnt very early on in life how important it is to make the most of every moment, as you never know when it might all get taken away.

Emily – Sarah has introduced me to so many artists who have inspired me to paint in new and exciting ways.

Sarah – With the encouragement of Emily I learnt to let go of precision and to stop being afraid of failure. As a result my art has blossomed.

PAGES 4–5: Patchwork Comfort Blanket, *Emily Powell, 2021, 150 x 480 cm, mixed media on canvas*
PAGE 7: Detail from Big Flowers, *Emily Powell, 2019, 100 x 100 cm, oil on canvas*
OPPOSITE: Detail from Colourful Boats, *Emily Powell, 2020, 200 x 200 cm, oil on canvas*
THIS PAGE: Sarah (left) and Emily (right) at the kitchen table, 1992

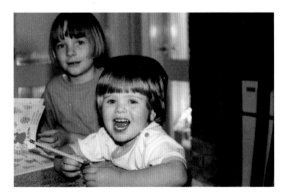

Emily's path to painting

School was many many resits of exams, and lots of red pen, frustration and disappointment. The system really wasn't set up for me and I only realise now how trapped it made me feel and what an enormous sense of failure it placed upon me. Art lessons were such a huge relief from the stress and pressure of the rest of school life. Struggling with dyslexia and dyscalculia, I spent my days imagining what life would be like if I could do art all week! No maths, no English; imagine if I could just draw and paint all day . . . ?

In 2008 I went to Norwich School of Art and studied Fine Art, specialising in sculpture. I found art school useful for giving me the space to develop a stronger sense of who I am as an artist. However, there was little careers advice and I felt a bit stuck. None of my peers were planning to be full-time artists and there was an expectation that we would all go out and find a 'proper job'.

Panicking that I couldn't be a full-time artist, I trained as a teacher for primary school children. Young children are such inspiring artists to be around and working with them was an incredible experience. However, the administrative tasks and the desire to give all I had to the children left me with little time for my art practice.

I then took a big leap, left teaching and set up a design company. This allowed me to practise creatively full time, and I learnt a lot about running a business, but I was still not able to just paint what I wanted without someone giving me a brief, and I longed for that creative freedom.

At last, I said to my husband Jack, 'Let's both leave our jobs and give it three months to see if we can make enough to cover our rent just with me painting and you framing the work.' On the third month we made our rent and we never looked back.

I've now worked with a selection of exciting galleries and I'm able to follow each and every painting whim I have. If I like toast, I'll paint toast. If the day is grey I'll paint huge abstracts that make me feel better. For me, this is real painting freedom and this is when my true happiness kicks in. I feel so satisfied now I've found this joy through painting and I finally know I'm in the right place.

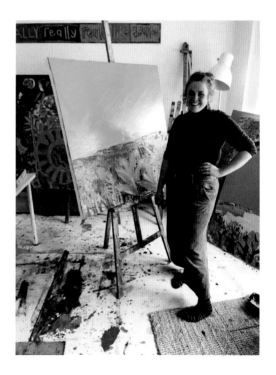

Sarah's creative journey

As a child I loved building sculptures out of cardboard boxes. Mum started me off early on with building dens and from there my ambitions knew no bounds – soon I'd made the Empire State Building and the Statue of Liberty! I painted footballers for Dad and illustrated handmade books with Mum. Art was a normal part of my everyday life.

At secondary school, my academic ability in subjects like maths and English began to edge out my creative side. My art teacher seemed to have no interest in teaching or inspiring her students and I still can't look at a mushroom without remembering how many lessons we spent drawing them! I persevered and began art GCSE, but it quickly became clear that the support just wasn't there, so I swapped to Latin, where the teacher was inspiring and I could guarantee the exam results I needed for university.

From the age of about fifteen, I did little art. I would enjoy making a journal of trips I went on, but these didn't have many drawings and my painting was almost non-existent. My time was spent revising for exams and playing sport, and the same was true at university. Working as a doctor was demanding and gradually edged out any residual art practice I might have enjoyed, though I see now it need not have done.

It was only when I was about thirty that I really started to develop my art practice further. For the first time since I left for university, Emily and I were living close together and she began to bring me out of my shell and help me see how much I still enjoyed art. She would take me out painting in all weathers and dream up ever more crazy ideas to get me to loosen up. I was getting increasingly run down by my work and in 2018 realised I needed to take a break and make a change. I loved the art I was doing with Emily and wanted to give myself the opportunity I'd denied myself when I was younger. I took time out of my work and signed up to do a full-time, one-year access to art course at our local college.

This was one of the best decisions I've ever made. I got the opportunity to redefine myself away from just being a doctor. I learnt that there was more to life than work and that my creative side really needed nourishing in order for me to feel well and be happy.

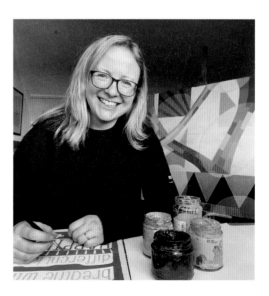

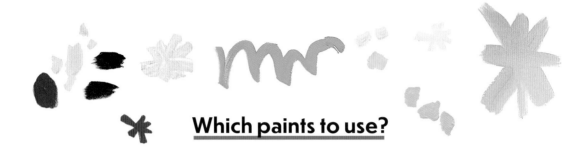

Which paints to use?

There are so many types of paint that we could never cover them all in this book, but here's a little introduction to the most common ones. Understanding the myriad paints and what specific purpose they are each good for can increase your chances of succeeding in whatever you're trying to achieve. However, that is not to say don't experiment and play, and we definitely encourage mixing up your media. Remember, there are no rules!

We often get asked about which brand of paint to use or how much to spend. In general, the more expensive paints tend to have better coverage and are nicer to use, but we often use basic ones with good results too. The main thing is not to get hung up on the kit and to just start painting now!

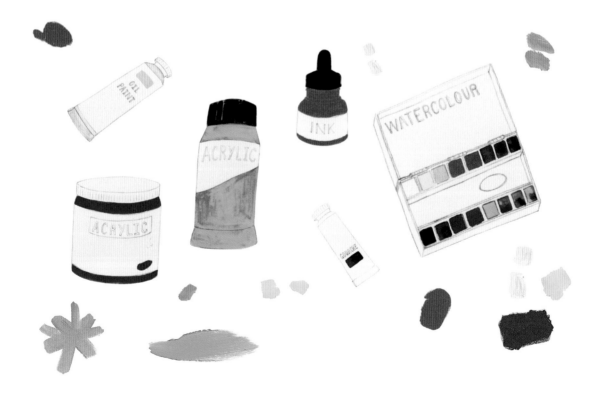

Acrylic

One of our favourites as it allows you to work fast and cover large areas. You can add water and make a wash or layer it on thick – and anything in between. It is fast-drying, but once dry it can't be worked into again, although it is easy to work on top of it. The colours are vibrant and there are inexpensive brands to get you started. It is also easy to clean your brushes afterwards as the paint is water-based – but be warned: it doesn't come out of clothes!

Oil

This has a reputation for being difficult to use but it can be a joy to work with. The colours produced are incredibly vibrant and you can continue to work the paint for days after you put it on the canvas. However, this does also mean you have to wait a long time for it to dry. It is also a bit of a faff to clean as you need something like white spirit for this, which will break down the oils.

An easy alternative to using the paints is an oil pastel or pigment stick. These give wonderful intense pops of colour and go really well on top of other paints, such as acrylics. They are also less hassle as there are no brushes to clean at the end.

Gouache

We both love working with gouache and tend to use it on paper, though it can be used on other surfaces, too. It is water-based and can be moved around after it has been put down, which does make layering more difficult – unless you want to mix the colours. It is similar to watercolour paint in its properties but it is much more opaque and gives wonderful, vibrant colours. Gouache is easy to work on top of with pencil or pencil crayon.

Watercolour

This is a medium we don't use much as it is hard to get really intense colour from it, but it can give some lovely results. It is mostly used on paper and we've found that the fancier the paper, the better the effect. Special watercolour paper can be expensive as it is very thick – it has to be to deal with the amount of water used – but if you want to get the best results it is worth the investment. This paint comes in tubes or blocks and by adding different amounts of water you can vary its thickness. You can then start using techniques such as layering wet paint on top of wet or dry areas to get all sorts of interesting effects. This is definitely a medium to spend some time experimenting with!

What to paint with?

There really are no rules here – brushes, sticks, wash cloths, mops, brooms, your hands! Switching it up and using unusual items can really push your art into new and unexpected places.

Each different implement makes a huge variety of marks. Why not try it out yourself?

Brushes – big, small

These don't need to be expensive, just get a pile of cheap brushes and make sure you have lots of different sizes and shapes to play with.

Sticks

Look for different shapes and sizes with pointy ends or flat sides.

Hands

Using the whole flat of your hand or just a finger, sweep it across the paint surface or make lots of individual prints.

Wash cloths

Great for applying large amounts of paint. Splat your paint onto the surface and wipe it around with the cloth. Try different amounts of dilution with water.

Brooms

Fantastic for larger pieces of work, it really is all about looking at what you have around you and having a go!

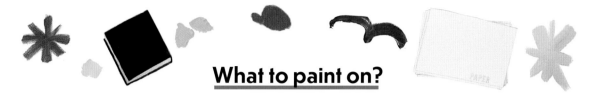

What to paint on?

Anything! We love the challenge of a new surface, though we appreciate that it's sometimes nice to use something more predictable. The more you play and experiment, the more you'll learn what you like and what suits you best for different techniques.

Paper – lining paper, sketchbooks

We mostly use paper with watercolour, gouache and sometimes acrylic paint. In general, the thicker the paper the better, as it can hold both the water and paint. Lining paper is fun for working on a big scale and sketchbooks of any size are easy to use on the go and outside.

Wood – wooden boards, old floorboards

Wood can give a lovely smooth surface for applying big flat blocks of colour. It can also give wonderful grain and texture, depending on how you treat it. We have painted on all sorts of wood – from floorboards to old shelves – and we enjoy the challenge of the interesting shapes. Finding old bits of wood is fun, however, if you want some regular pieces or specific sizes, most big hardware stores will cut down huge pieces of plywood or similar to the sizes you want. This can be a cheap way of getting lots of surfaces to paint on.

Cardboard – packaging boxes, museum board

Not only is cardboard a great surface to paint on, you can build things out of it first and then paint them! Hang on to your old packaging and have a good old play . . .

Museum board is a bit fancier and is a great lightweight alternative to wood, with a smooth surface and ease of sizing.

Canvas – primed/unprimed, stretched/unstretched

Most canvases come stretched and primed (painted with a white underlayer) and ready to go, and these are a great place to start. If you fancy trying other options you can get canvas that hasn't been primed, which gives a different feel. You can also get canvas in a roll rather than on a frame, which can be good for storing and carrying but usually needs stretching out for final display.

PART 1

Where to start

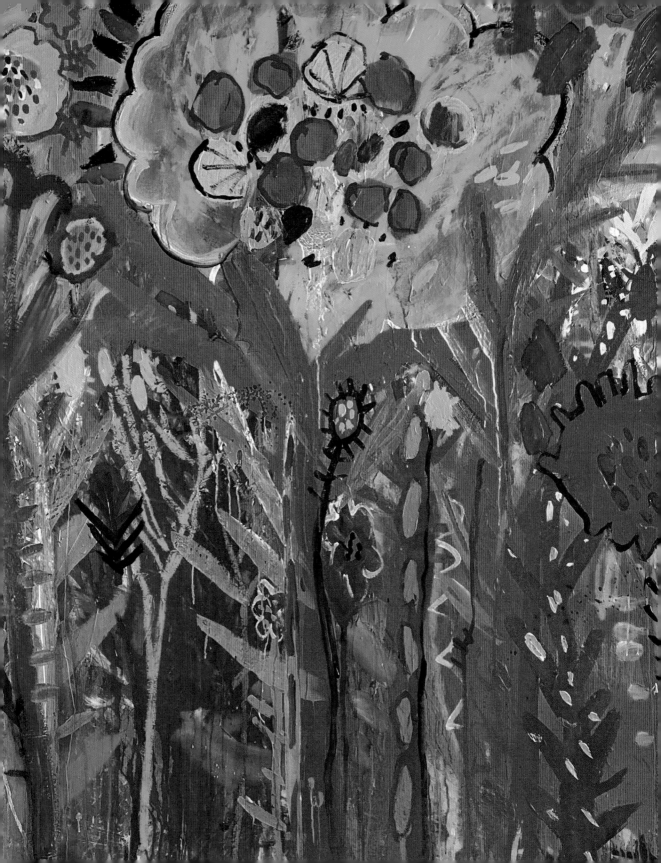

1. I am an artist

'My story as an artist is who I am.' - Faith Ringgold

A fresh mindset

We believe very strongly that *anybody* can be an artist.

All you need to do is make the decision to be one, no exams required! It's all about your mindset, and when you realise how important creativity is in your life, you just need to make a positive choice to let the artist in you shine.

This chapter explores how you can make art a part of your life. We help you challenge your self-doubt scorpions and show you the power of a positive choice. We'll introduce you to painter Emily Kame Kngwarreye, whose story shows how art can be a way of life – and you'll see that author Emily's reaction to her art is exciting and powerful.

After that inspiration it's time for your first task. Remember when you were about seven years old and you drew freely, without judgement? This is where we will take you: uninhibited play, putting brush to paper and making your mark.

> '*Once I knew that I wanted to be an artist, I had made myself into one. I did not understand that wanting doesn't always lead to action. Many of the women had been raised without the sense that they could mold and shape their own lives, and so, wanting to be an artist (but without the ability to realize their wants) was, for some of them, only an idle fantasy, like wanting to go to the moon.*'
>
> - Judy Chicago

PREVIOUS PAGE: Full of Good Feelings, *Emily Powell, 2019, 200 x 200 cm, acrylic and oil on canvas*
OPPOSITE: Along Came Bea, *Emily Powell, 2021, 150 x 180 cm, mixed media*

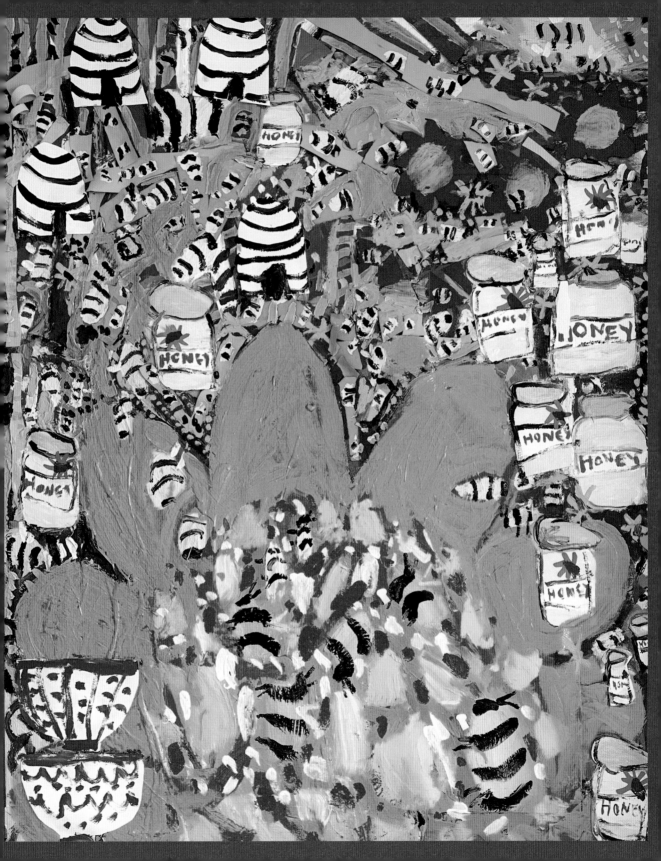

When do you
become **an artist?**

This is a question that perplexed us for ages. But then one day we were sitting down chatting with a good cup of tea and we suddenly realised: **you're an artist whenever you choose to be!**

Artists come from all walks of life, they have a wonderful variety of experiences and there are no qualifications needed. It doesn't matter whether you're a mum who gets creative with her kids on rainy weekends, or you did an art degree but decided to become a banker, or you have your paintings hanging in the Tate. **You are an artist.**

When we realised this, we couldn't believe how obvious this was and so we set about trying to work out how we'd missed this truth for so long . . . What had stopped us from calling ourselves artists?

'Artist' does not have to be an exclusive identity. Only by finding and owning all our different parts do we truly begin to understand ourselves. This is a work in progress throughout our lives but why not get the artist piece in place now?

'The wonderful thing about being an artist is that there is no end to creative expression.'

- Loïs Mailou Jones

ABOVE: All the Feelings the Sea Brings, *Emily Powell, 2021,*
100 x 120 cm, acrylic on canvas
BELOW: At the Seaside, *Sarah Moore, 40 x 55 cm, acrylic on wood*

Emily – Despite doing an art degree, I was always looking for the next achievement to feel that I was accomplished enough to call myself an artist.

I'm going to be an artist when…
…I've done an art degree
…I've sold a piece of work
…I've got my work in a gallery
…I'm making a living from my art
…I'm elected to the Royal Academy

These conditions all hinged on external appreciation of my art, and I eventually realised I had this all the wrong way round! This way of thinking could go on forever because I would always find another reason why I couldn't call myself an artist … yet. There was no end in sight, because I was always looking for external approval. Instead, I needed to look inside and tell myself: 'I am an artist'. Once I managed to do this I had a wonderful sense of freedom in my artistic practice and I've never looked back!

Sarah – I loved art but had always found myself pigeonholed into other categories. My teachers assumed that being good at other subjects meant I wouldn't need or want to be an artist and that I would find fulfilment elsewhere. It took me a long time to realise this wasn't true, and actually, like everyone, I can and do have many identities that are held simultaneously. Once I accepted this I was able to embrace art and bring being an artist back into my life.

Positive effects of
choosing **to be an artist**

We realise that you might be thinking 'that's ok for them to say, but it doesn't apply to me.' Well, here comes the good news – it does apply to you! The only difficult bit is that you need to make a positive choice. If you have no interest in art and find throwing paint around to be dull and tedious then you could quite reasonably choose not to be an artist. However, if you enjoy the process of making things or you've ever had half an inclination to create, then we absolutely recommend you choose to explore that further and be an artist.

When you make a choice like this you are setting yourself up for success – all of us tend to feel positive about the things that we've made a choice about, even if there are difficulties along the way. It takes a lot of courage to say 'I am an artist' and to own it. By taking control and choosing to be an artist you are also making a decision for yourself that you will make time for art in your life. We know that there are many obstacles and hurdles to making art and it might seem like a really difficult journey, but this book will guide you through and over them and remind you of the fundamental importance of including creativity in your life.

❚ _OPPOSITE: Art is About Life, Sarah Moore, 2021, 30 x 42 cm, gouache on paper_

Sabotaging scorpions

We totally understand that self-belief and positive vibes get challenged regularly, and that's ok. In fact, it's normal and healthy to doubt yourself from time to time. If you didn't do the occasional self-check-in on how things are going then you could arrogantly push forward without ever evaluating what you are doing and never learn anything new. The problem comes when these challenges crush your self-belief and prevent you from pushing forward.

The way we like to think about this problem is by imagining such thoughts as sabotaging scorpions of self-doubt. What we artists need to be able to do when a scorpion scuttles into view and threatens to sting us with self-doubt is to recognise it, then to deal with it effectively. These pesky scorpions come in different shapes and sizes, primed with different doubts, but with a bit of forethought you can work out ways to tackle each and every one of them.

> 'I was once afraid of people saying "Who does she think she is?" Now I have the courage to stand and say, "This is who I am."'
>
> - Oprah Winfrey

So, how might this work in practice? Imagine you are happily painting away when a scorpion starts walking towards you. This scorpion was sent by that art teacher you had at school who told you that you were hopeless at art and it is coming to tell you that the art teacher was right and you'll never be an artist and how dare you think you might! Instead of being scared, you stand up to the scorpion and shout 'Who made you the judge of who can be an artist?'. The scorpion will – trust us – stop in its tracks. It doesn't have an answer. It can also see how you are unafraid and angry with it for disturbing your painting session. Deciding this is a pointless task not worth getting stamped on over, the scorpion turns round and scurries away. You can then happily get on with your painting.

This isn't an easy exercise and it might not work immediately, but we promise it's worth persevering with. You'll find that over time there will be fewer scorpions full of the old sabotaging self-doubts wandering across your path, or you'll be so engrossed in your painting you might not even notice them.

Scorpion: How can you call yourself an artist when you aren't a professional?

Sarah: Being an artist is an important part of who I am, I'm doing this for me and nobody else.

Scorpion: You're not an artist, you don't paint the world as I see it.

Emily: I paint the world as I see it and this is what matters. We are all different.

Over to you – So what do your scorpions say? Why not write out a few of the commonest scorpions that visit you? In fact, why not draw them? Give them colours and shapes and even names and then work out what you're going to say next time they try to visit you!

Emily Kame Kngwarreye
1910–1996

ABOVE: *Emily Kame Kngwarreye painting* Wild Yam 2 *in the Utopia region, Central Australia, 1995*
OPPOSITE: Linear Yam Dreaming, *Emily Kame Kngwarreye, 1993, 134 x 90 cm, synthetic polymer paint on canvas laid on linen*

In Utopia, in the remote Northern Territories of Australia, Emily Kame Kngwarreye would sit for hours on the red earth of her ancestral homeland, painting huge canvases spread out on the floor before her. Emily only began painting with acrylic on canvas in her seventies, when the materials were made available in her community, but she was prolific, producing around 3,000 paintings in the eight years before her death. Despite only gaining access to these materials later in life, Emily had always been an artist, telling the traditional stories of her land through ceremonial body painting and drawings etched onto the earth.

Emily's painting was both instinctual and based on many thousands of years of tradition and ceremony. Taking all of these influences together, Emily produced spectacular paintings that transcend the boundaries of culture and environment, speaking directly to audiences worldwide. Although often compared to artists such as Claude Monet and Jackson Pollock, Emily was without influence from the traditional Western art narratives. Indeed, when shown the work of famous modernist painters, she reportedly asked, 'Why do those fellas paint like me . . . ?'

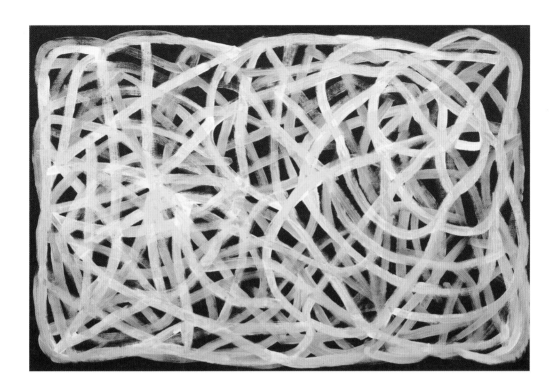

What can we *learn* from Emily Kame Kngwarreye?

1. The emotive power of art is universal and artists can bring people together. The intricate stories behind Emily's work might only be understood as she intended in a very local area, but viewers all over the world can still find pleasure in their own emotional response to the energy of her work.

2. If you make your art about your life and tell your story, you'll make your best work. Emily Kame Kngwarreye's work is not trying to put across any perspective other than her own and her paintings speak for themselves in their power of expression.

3. If you dedicate yourself to being an artist it's amazing how much work you can produce and this in turn feeds into the speed at which your work develops and changes. Emily was an artist all her life but in the final years when she painted in a medium that could be stored, it became clear just how prolific she was and what effect this had on her style over a short time.

Emily's reaction to Emily Kame Kngwarreye

Emily Kame Kngwarreye's work is so true to herself and as a result has huge emotional power. She is a fabulous example of our fundamental need as humans to make marks and tell our story, no matter what the materials available. Emily doesn't hunt down critical acclaim, she just does exactly what she needs to with the paint. However, it's amazing how much emotional impact this way of working can have, both on the artist and on other people when they view it. This is the real-deal raw stuff that is so important for our mental health. What a true inspiration.

My hands are always itching to paint after thinking about Emily Kame Kngwarreye. One of the paintings that she inspired me to make was this huge abstract piece. It has no subject, it is a series of marks I needed to make and colours I needed to see. It was a reactive piece. I don't remember thinking 'I'll put that circle here and this blob there', I worked close to the canvas without thinking, just making marks next to other marks, each one a reaction to the last. This process was exactly the same with colour; there was no grand plan. I started with pink, this needed green to go with it as I adore that colour combination, then found I was adding gold and before I knew it I had this huge painting.

OPPOSITE: Emily standing in front of Magical Garden, Emily Powell, 2019, 200 x 220 cm, acrylic and oil on canvas

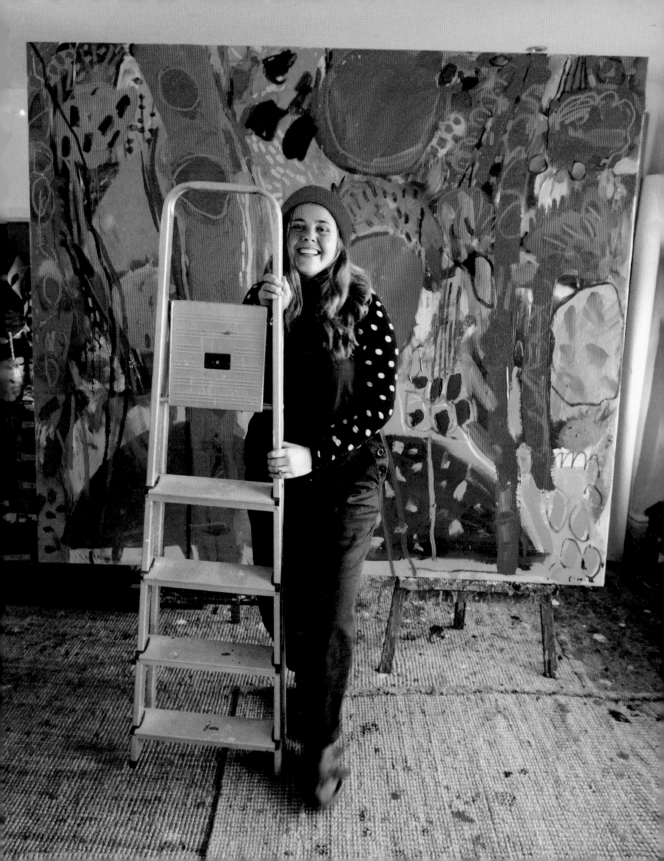

Making your mark

This is an exercise our dad taught us and it's called 'taking a paintbrush for a walk'. This task is purely intuitive and we want you to concentrate on mark-making and colour. It sounds simple but it can become completely absorbing and it's a great way to warm yourself up for painting.

1. Take a piece of paper – the bigger the better as it gives you more room for expressing yourself.

2. Gather together paint colours you love (there are guides to paints, surfaces and materials on pp. 12–15).

3. Pick a colour and load your brush with paint and a bit of water to make it last.

4. Drag your brush around the page in one fluid motion – in and out, up and down, zig-zag and curly, crossing back and forth.

5. Now it's time for the really absorbing bit – you'll have made all sorts of shapes on the page and then colour them in. Use colours you love seeing together, experiment with new combinations, feel your way through the piece.

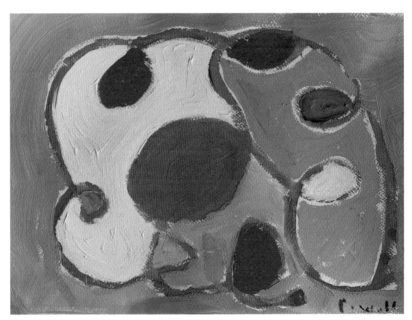

ABOVE: Sarah's task
BELOW: Emily's task

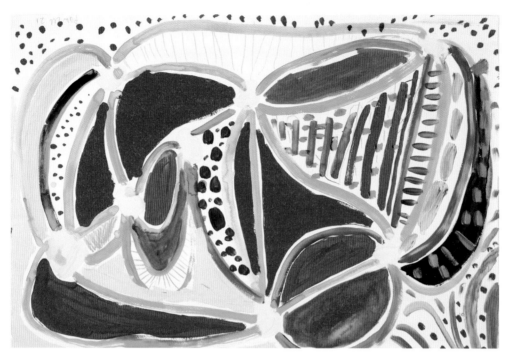

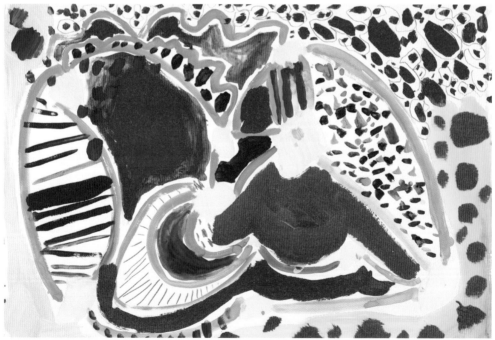

More, more, more!

Paint ten dots on a page, connect them any way you like, then colour in the sections. Wham bam you have an abstract painting! We could make these for hours. Good art is all about letting go and not over-thinking. Enjoy the fun.

OPPOSITE: Emily's extension tasks
BELOW: Sarah's extension task

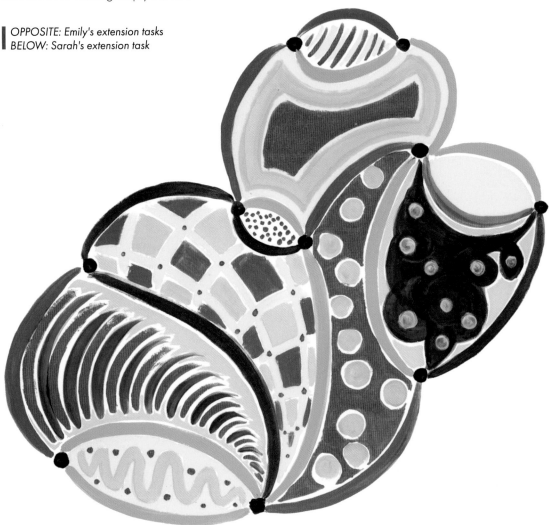

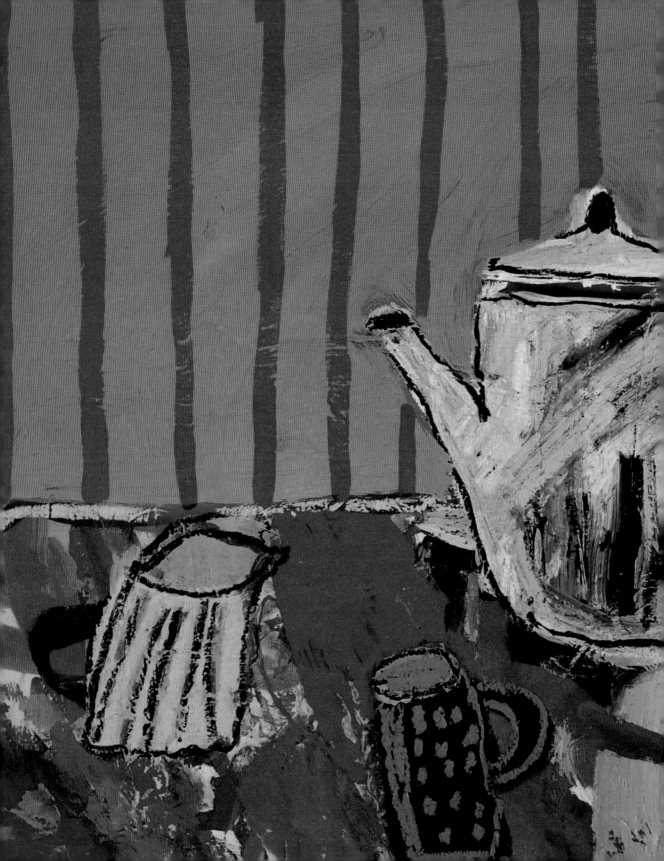

2. Looking after yourself

'You can't use up creativity. The more you use, the more you have.'

- Maya Angelou

Press pause

When was the last time you pressed the *pause* **button and took some time to think about what makes you** *happy***? Or even to do something you already know brings you** *joy***?**

In modern life it's often very difficult to find time for self-care and we also tend to put our own happiness below that of our friends and families. This doesn't make us bad people – it's important to look after others! However, we can't look after family and friends if we don't look after ourselves as well.

This chapter is going to help you develop an awareness of what self-care means for you and how to build strategies to look after yourself and especially your creative self. We start on this journey with an introduction to recognising where you get your energy from and how to charge your batteries. This is followed by the power of saying 'NO!' and the cake of self-care (sorry, it's not a real cake!). Our artist inspiration is Agnes Martin, who felt her best work was created when she started living in a way that made her happy. We challenge you to spot the similarities in Emily's reaction to happiness! Then it's over to your task for this chapter, where it's time to work out what type of artist you are and how to nurture your creative self.

PREVIOUS PAGE: Time For Tea, Emily Powell, 2018, 100 x 70 cm, mixed media on canvas
TOP RIGHT: Emily standing in front of a work in progress
BOTTOM RIGHT: Sarah out sketching

'Daring to set boundaries is about having the courage to love ourselves even when we risk disappointing others.'

- Brené Brown

Emily's top tip – I've spent a lot of time and energy working out how to look after myself and I truly believe the effort has been worth it. I am definitely happier and more fulfilled as a result. I would recommend putting in the effort as soon as you can because it can make an absolutely huge difference to your life.

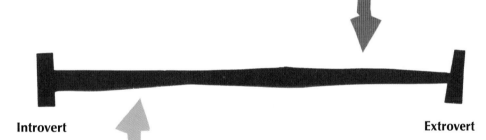

Introvert

Extrovert

Sarah's top tip – Susan Cain's book *Quiet: The power of introverts in a world that can't stop talking* blew my mind. It's the only book I've read twice and I've lent it to so many people it's falling apart. This book not only allowed me to understand myself but also those around me and it gave me the tools to make the most of my introversion. I recommend it to everyone, wherever you fall on the scale!

What's *your* **power source?**

There's no one size fits all to looking after ourselves. Each of us is a unique individual with an exclusive set of experiences. What's key is that you are able to recognise what's important to you and then use this knowledge to look after yourself even better in the future.

We both feel it's crucial to maintain our energy. If we have plenty of energy we are able to expend it on things that bring us joy, like painting. So, where do we get our energy from and how can we best recharge our batteries?

Introversion and extroversion have many connotations but the core meaning relates to where we get our energy from. Introverts get their energy from inside and find highly stimulating environments exhausting. They need alone time to recharge. Extroverts get their energy from outside, find time alone saps their energy, and they need to recharge through social interaction and stimulating environments. Contrary to popular belief, most people don't fit exclusively into one or the other of these types. We all fall somewhere along a spectrum and where this is can change throughout our lives. There is no right or wrong in where you land on this spectrum. What matters is that you can recognise where you are and take steps to ensure you keep your energy at a level that allows you to enjoy yourself!

Emily – I love talking to people and listening to their stories. Having a day out at a gallery or an exhibition with people is one of my favourite routines that fills me with energy. I also find going for a walk energizes me as I spend time outside and engage with the community. My energy is reactive and once my battery is charged I head to my studio and use it to express the wonderful feelings and moments I've experienced.

Sarah – I'm happy to spend time alone, with plenty to think about and my own ideas keeping me busy. I enjoy a meaningful conversation with a friend much more than small talk and socialising in a big group. I do enjoy a party and can have great fun, but for me this must be followed by a period of quiet time alone to recover. That period of reflection is when I get my energy, whether that's by reading a book, painting in my studio or walking on the coast path.

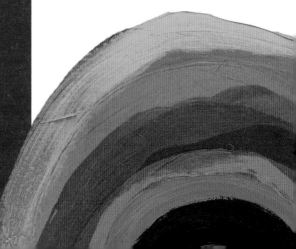

Low
Stimulation

High
Stimulation

Charging

INTROVERTS

EXTROVERTS

Draining

High
Stimulation

Low
Stimulation

It's *ok* to say NO!

Say yes when you want to say yes; say no when you want to say no! It's that simple – or is it?

First things first: saying no does not make you a horrible person. It does not mean you are rude or selfish or that you don't care about others. It means you are making time and space for you. In a life that could otherwise be consumed by what others want from you, it is important to take time to nurture yourself and your creativity. You'll be amazed at how much you enjoy all the other aspects of your life once you start to make yourself the priority once in a while.

Saying yes is easy, saying no is hard. We grow up learning that it is rude to say no and we develop a deep desire to please others. We can easily get trapped in a cycle of saying yes to everything to the extent that we lose sight of what else is out there and what is truly important to us.

So how do we move from saying yes to everything to reprioritising our lives and learning to say no? The best way we have found to think this through is by asking ourselves:

1. Who am I doing this for?
2. What else could I do with that time?

The easiest way to begin reprioritising is by giving yourself time to think about your answer. We find that if we don't do this we are in danger of automatically saying yes to everything! One way you might do this politely is to say you need to check your schedule before you can respond. This gives you time to ask yourself the questions and work out what is best for you.

TOP TIPS

Emily – Practise saying no to small things first and build up from there. An example could be if a neighbour asks you whether you can wait in for a parcel for them. You're not sure of your plans but you don't want to be tied down that day. Apologise and explain that you're unable to wait in. I sometimes think of myself as the neighbour and if someone apologised and said no to me I would be more than fine with it.

Sarah – Being self-employed has been a steep learning curve for me. It's very easy to say yes to every opportunity that comes along 'just in case'. I've realised, however, that by saying yes to things I don't want to do, I've reduced the time available to say yes to the things that excite me.

Over to you – Now it's your turn to have a go at saying no! Build it up slowly and you'll soon find that the more you say no to the things you don't want to do, the more time you'll have for the things you do want to do!

'Saying yes to happiness means learning to say no to the things and people that stress you out.'

- Thema Bryant-Davis

The cake of self-care

One idea that we have found to be helpful in understanding how best to look after ourselves is called Maslow's hierarchy of needs. We have adapted this psychological model into our cake of self-care. The underlying concept is a pyramid of five levels, with the ultimate goal being to reach the top layer, in which we are able to be creative and fulfil our potential. Not every level has to be complete before moving on to the next one, and over time the relative importance of each layer or concepts within those layers will change.

For us, the top layer equates to the creative act of painting and the fulfilment of the lower levels improves our chance of success and enjoyment at the top level. In order to understand how we are motivated and how we can achieve our goal, we sat down together and reviewed each level. We started by exploring the bottom two layers, which Maslow termed our 'basic needs' (physiological needs and safety and security):

> **Sarah** – I always need to have a cup of tea on the go.

> **Emily** – I need a flow of fresh air through my studio to keep me stimulated.

We share ideas for how to create a space of your own for painting on pp. 146–147.

Then the next two layers, the 'psychological needs' (love and belonging and esteem):

> **Emily** – I find having a network of other artists to talk to incredibly helpful.

> **Sarah** – Being able to sell my work really increased my self-confidence.

We found it really helpful to have a think about these ideas first by ourselves and then together to help us spot important things we might have missed:

> **Sarah** – Emily was quite right in pointing out that I work much better after a piece of cake!

> **Emily** – Sarah pointed out that I am much more creative if I get out of the house and go for a walk.

The delicious topping on the cake is the feedback loop that's established once you are operating in the top level. This is known as 'intrinsic motivation', where the desire to be creative is generated from inside you and the more you create, the more you want to create until it becomes an upward spiral of self-fulfilment.

Self-fulfillment

spontaneity

creativity

problem solving

Esteem
e.g. self-confidence, approval, recognition

Love and belonging
e.g. friendships, social connections, networks

Safety and security
e.g. employment, resources, health

Physiological needs
e.g. food, water, shelter, sleep

Over to you – It's time to get your thinking cap on and consider what constitutes the foundation of your pyramid, then you will be ready to fly!

Agnes Martin
<u>1912–2004</u>

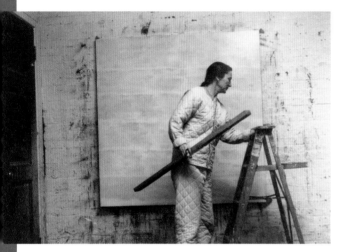

ABOVE: Agnes Martin in her studio
OPPOSITE: Summer, Agnes Martin, 1964,
59.4 x 59.4 cm, watercolour, ink and
gouache on paper

'When I think of art, I think of beauty. Beauty is the mystery of life. It is not in the eye, it is in my mind. In our minds there is awareness of perfection.'

- Agnes Martin

In the 1950s and 60s, Agnes Martin was living in hectic New York, at the heart of the Abstract Expressionist movement, surrounded by some of the most famous artists of the day. The energy of this life must have been inspiring but eventually this highly stimulating world proved too intense. Agnes set off travelling, finally arriving in arid New Mexico where she settled on a remote hill, twenty miles from the nearest highway, and built herself a house and studio. She had finally found the perfect environment for her art to blossom.

Agnes was insistent that she didn't want her paintings to be interpreted, saying 'From music they accept pure emotion but from art they demand explanation.' This made no sense to her, it was up to the viewer to see the beauty of the work and each viewer would see something different. Providing the reasoning behind this would interrupt this process. She explained her theory by showing a rose to a young girl. 'Is this rose beautiful?' she asked. 'Yes, this rose is beautiful,' said the girl. Agnes put it behind her back and asked 'Is this rose still beautiful?'. 'Yes, this rose is still beautiful,' said the girl. 'Well,' said Agnes, 'that shows you that the beauty is not in the rose, the beauty is in your mind.'

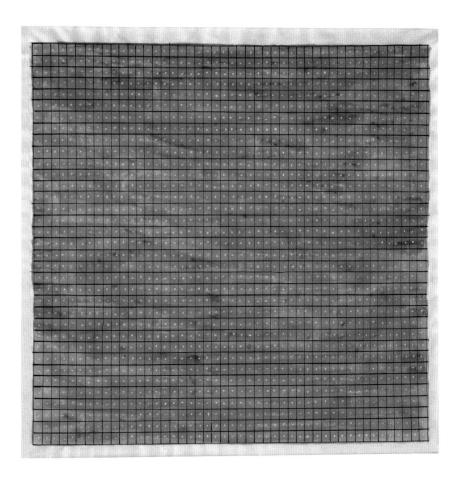

<u>What can we *learn* from Agnes?</u>

1. We all need different environments in which to work and these can change through our lives. To some, a carefully tidied, white-walled space might be the perfect recipe for painting, while others might thrive in a messy shared studio.

2. You'll make your best work by being true to yourself, saying no to the things that are harmful to you, and developing those that nurture you.

3. Your paintings can be pure abstracted emotion, whether peaceful contemplation or wild energy, and you don't have to explain them to anyone. Why not see what people make of them without explanation?

Emily's reaction to Agnes Martin

Agnes's work feels independent and empowered. She creates her own path and does her own thing, which is so refreshing to see in this modern world where we are told to stick to predefined pathways.

I really relate to the way Agnes uses emotional expression to create her work. After a day trip to Burgh Island, in Devon, I returned to my studio and created this visceral, emotional response to the waves, the rocks and the shapes in the sand.

I didn't worry about whether there would be people who would not understand it. For me, it was a powerful form of self-expression and as Agnes says, 'I paint with my back to the world.' I didn't think about my audience, I just let go and painted what I felt, and what I thought was beautiful in my mind.

'I paint with my back to the world.'

- Agnes Martin

LEFT: Detail of Abstract Burgh Island
OPPOSITE: Abstract Burgh Island, Emily Powell, 2020, 200 x 200 cm, mixed media on canvas

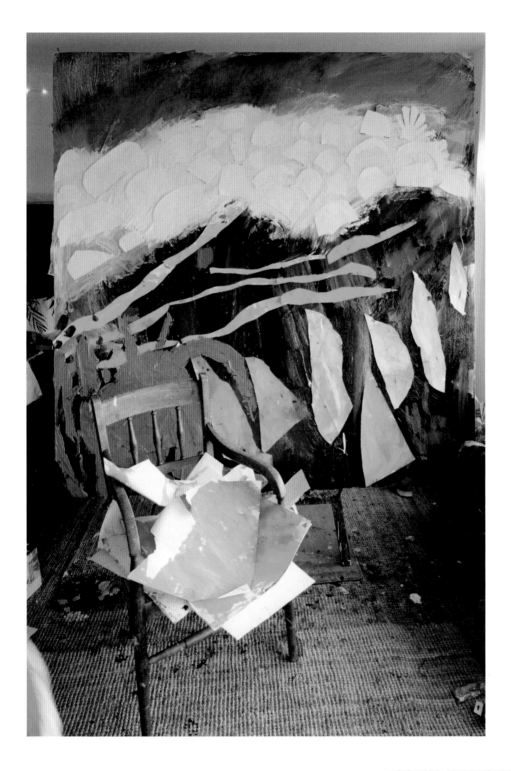

Being good to yourself

This task is all about taking some time to recognise what fills your heart with joy and fires you up for painting. This task is all about you. You are making this work only for you and don't have to be able to explain it to anyone.

1. Start by writing a list of the activities that you do in your daily life. There is no predefined list because we are all so different. You might have some activities that take up most of your time, like working or caring for somebody, but don't forget to include the other things that make up your day, such as cooking, drinking a cup of tea or walking the dog. You'll see some more ideas in our examples – no prizes for working out we both love having a bath!

2. Now take a piece of paper and some masking tape and divide the paper into sections, as we have done in our examples opposite. You should have six rows of roughly equal size and a small column down the right. If your paper feels too small, just tape a few pieces together.

3. In the column at the end of each row, pick one of your daily activities and write it down.

4. Now for the fun part! For each activity, we want you to draw how you feel when you do that activity. Pick colours that go with those feelings and make marks that show your emotions. Have a look at our examples for inspiration, but remember there's no right answer here – it's all about you.

5. Once it's dry, peel off the masking tape (don't worry if it takes some of the paper with it) and have a look at what you've made.

6. You should be able to see how the activities affect you at a glance – which are calming and which are energizing, those that are dull and those that are exciting.

7. Now have a think about how you could increase the time you spend doing the activities that give you energy and inspiration.

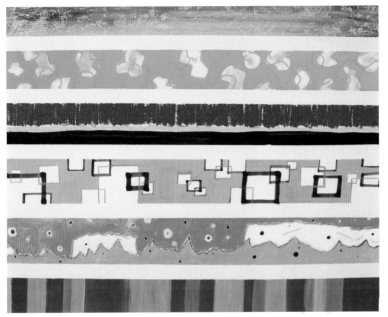

Having a bath

Walking the dog

Reading a book

Working on a computer

Doing the garden

Paddle boarding

▌ *Sarah's task*

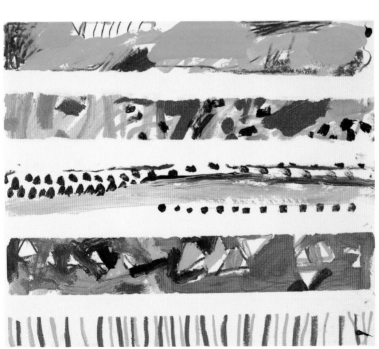

Having a bath

Loading the dishwasher

Watching the telly

Walking by the sea

Stroking the cat

▌ *Emily's task*

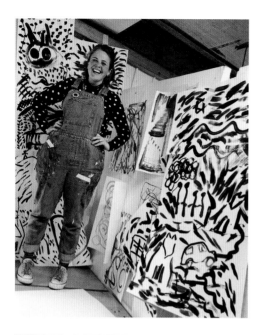

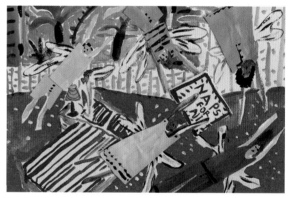

ABOVE: Clockwise from top: Emily standing in front of work in progress; Sarah's creative space and cat; The Nap Fairies, Emily Powell, 2021, 40 x 35 cm, gouache on paper; Being good to ourselves; Sarah painting

OPPOSITE: Detail of Rainbow Abstract, Emily Powell, 2021, 45 x 80 cm, mixed media on paper

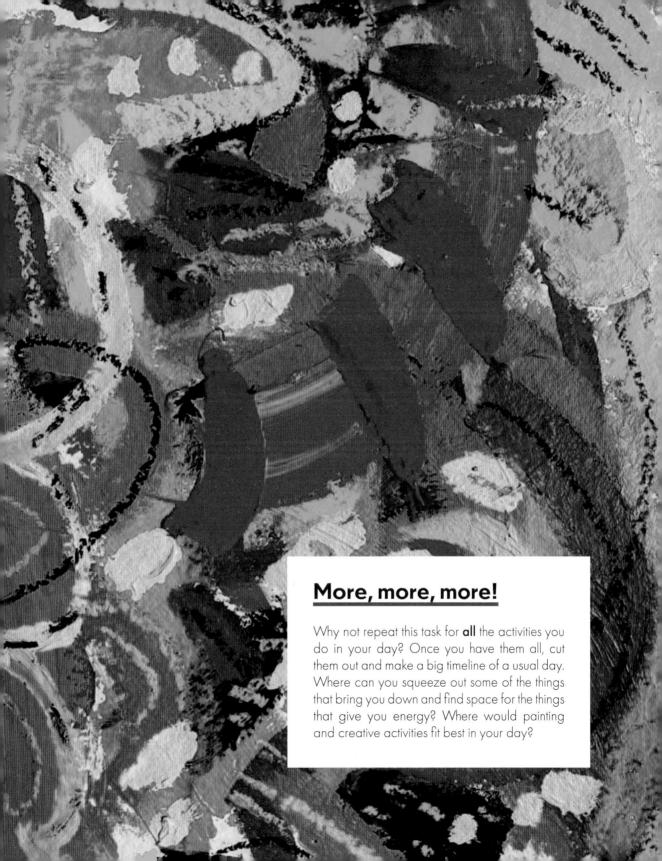

More, more, more!

Why not repeat this task for **all** the activities you do in your day? Once you have them all, cut them out and make a big timeline of a usual day. Where can you squeeze out some of the things that bring you down and find space for the things that give you energy? Where would painting and creative activities fit best in your day?

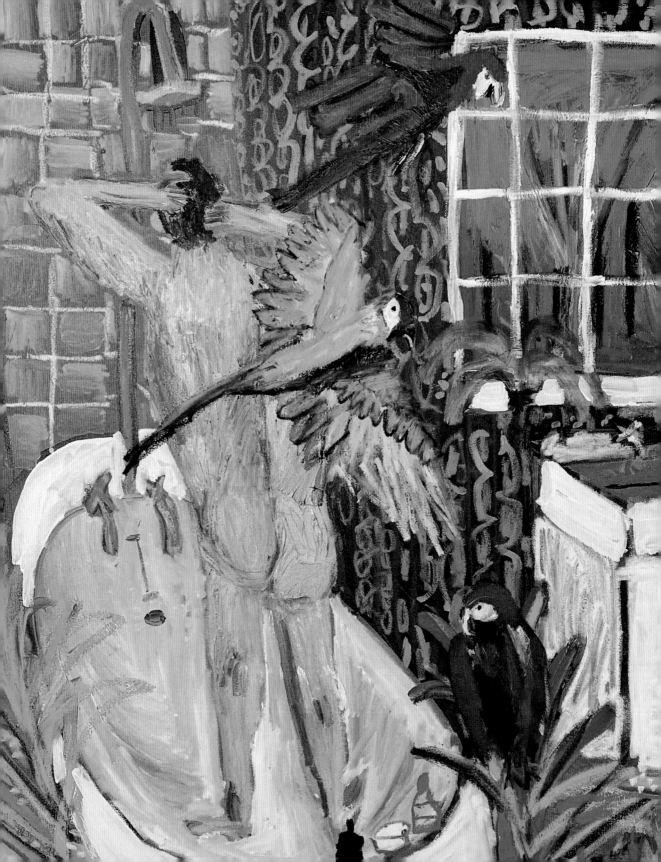

3. Breaking
the rules

*'If you obey all the rules,
you miss all the fun.'*

- Katharine Hepburn

Find your style

Want to know a *secret* to painting with joy? Rip up the rule book!

All those rules at school? Forget them. When you draw a teapot that doesn't look like a teapot? Celebrate your style. Having the ability to step outside of the box and show your natural style is a superpower. We want you to learn to love your own ideas and expression, not be constantly striving to fit in with what everybody else is doing. This chapter will get you painting with freedom through an introduction to your instinctive creativity and an exploration of why there's no wrong answer in art (Hooray!!). We share with you the fabulous life and work of pioneering Irish abstract artist Mainie Jellett and Emily shares her reaction to Mainie's art, which ignores accepted conventions. Finally, your task is to create squares of joy that will encourage you, quite literally, to break out of the box.

Ultimately, we want you to remember that you can paint on anything, with anything, in any way you like – but most importantly, you can paint with joy and back yourself all the way.

> *'There are no rules. That is how art is born, how breakthroughs happen. Go against the rules or ignore the rules. That is what invention is about.'*
>
> *- Helen Frankenthaler*

PREVIOUS PAGE: Paradise Falls, *Emily Powell*, 2019, 100 x 100 cm, oil on canvas
ABOVE: A Good Bunch, *Emily Powell*, 2018, 32 x 45 cm, acrylic and oil on canvas

Instinctive creativity

It is often said that you need to know the rules in order to break them. Well, for those of you thinking 'Uh oh, I don't know the rules,' here's the good news: we don't think this is true. You don't need to waste time learning the rules, just dive in and have a go! We believe this instinctive approach to painting brings joy. If you paint like this you'll probably break a pile of 'rules' along the way but you won't know you're doing it, which is very liberating!

Have you ever watched a small child paint? Really watched them? Obviously this isn't practical for everybody, but if you can then we totally recommend you try it. Watch what they do. How do they hold the brush? Do they stick to the paper or move towards the walls? How do they look when they feel the squelch of paint between their fingers and toes? Children don't know the rules, they don't have a concept of the finished piece but they will be deeply engrossed in enjoying the process. That's what we are striving to achieve.

Through this process of experimentation you might come up with certain methods that suit you most but it's important to go on challenging these self-made rules. If you don't, you'll never learn and develop. Look at the works of famous artists and you'll see how they change over time as each artist moves through various experimental stages and develops different styles. A great way to see this for yourself is to visit an artist's retrospective and wander through their work as it evolves over their lifetime.

> 'The creative process is a process of surrender, not control.'
>
> - Julia Cameron

Sarah – Our school system brings us up to perform in exams, to expect to be able to get things right. Like a lot of people, I really struggled with this concept when it came to art. I was used to being able to predict what would get me good marks and the approval of my teachers, but this didn't work in art classes. I became stuck doing strictly representational drawings that were more predictable in their outcomes. It took me years to recognise how my creativity had been stifled and to unlearn all that I had learnt. I am still unlearning and I totally recommend it!

This is fun on the boat I like travelling on the boat.

CLOWISE FROM TOP: Red Rabbit, *Sarah Moore aged 5, 1990;* Fun On The Boat, *Emily Powell age 6, 1996;* Teddy And Tiny, *Emily Powell age 5, 1995.*

Escaping *the Box*

You know that sense of freedom that comes when you're operating outside the confines of rules and expectations? That's what we want you to feel when you're painting. It's not always an easy place to get to but your true artistic voice will be at its strongest when you are uninhibited, running wild and free in your mind and on your canvas.

One way to imagine this is to think of a box filled to the brim with cluttered rules and what people expect from you. If you remain inside the box you'll keep bumping up against the restrictions and this stops you from having the space to think. Step outside that box, however, and you'll find that creative space your brain has been craving.

OPPOSITE: There Are No Rules, Sarah Moore, 2021, 30 x 42 cm, gouache on paper

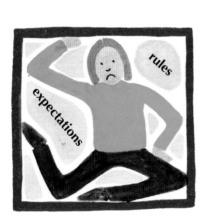

Think *outside* **the box**

there are
NO RULES
that is how
ART
is born
- H. FRANKENTHALER

Why there is *no* wrong

There's no right answer in art and no formula that gets you there. Art is at heart subjective. True, people have tried to make art objective, to measure and criticise it and tie it up in rules, but this has never really worked. Artists have always snuck around the side or just driven straight through the middle of these barriers to creativity. Much of what we've learnt about the energy and freedom of expression that can come from breaking the rules and thinking outside the box comes from learning about such artists.

We'll be introducing you to Irish artist and rule-breaker Mainie Jellett later in the chapter, but let's break our own rule of one artist per chapter(!) and have a quick look here at Hilma Af Klint. Born in 1862, and working in an era when female artists were only considered able to paint small reproductions of images that already existed in the world, such as flowers, Hilma af Klint was a trailblazer. She created colossal works of abstract art in colours that were highly unusual for the time and was making truly abstract art long before the well-known 'founders' of the genre, such as Piet Mondrian and Wassily Kandinsky. Hilma followed her instinct and her passions, despite the resistance she received from the establishment. As a result the work she produced was truly ground-breaking.

If you're looking for further artists for inspiration, why not try the work of Helen Frankenthaler, who developed her own method of 'soak-stain' painting, or Amrita Sher-Gil, who stepped outside her classical European-influenced training to depict the life of people in India through her paintings.

SUBJECTIVITY

Sarah – My taste in art has changed dramatically over the past five years. I used to love tiny, detailed pencil drawings, but now I crave the power and emotion of the huge canvases of Abstract Expressionists such as Lee Krasner. I still love a simple sketch but, for me, going to see the work of artists such as Lee Krasner and understanding the emotional expression behind their work transformed my understanding and appreciation of their art.

Emily – What I crave from the canvas changes each day; sometimes it's the huge bonkers abstract that shouts from the canvas and sometimes I find myself needing to work a lot more literally. I listen to what I need from the canvas and dismiss the worry of 'Will it look good with my style?' or 'Should I do a series?'. Who cares? True authentic work comes from what I'm feeling that day.

Over to you – One of the best ways to see subjectivity in action is to pick a painting and look at it with a friend. What do you like about that painting? What do they like about it? Be honest with each other. Don't say what you *think* you should say about it.

OPPOSITE: Detail of *Tremenheere Gardens, Emily Powell*, 2020, 100 x 100 cm, oil on canvas

Mainie Jellett
1897–1944

ABOVE: *Mainie Jellett in her studio, 1920s*

Dublin was not ready for Mainie Jellett in 1923, the year she returned to Ireland after pursuing her art education in London and Paris, bringing her new ideas and a radical modernist style with her. When she submitted her piece *Decoration* to the Dublin Society of Painters' exhibition she received scathing reviews, calling her work 'subhuman art' and 'an insoluble puzzle' and suggesting that she was suffering from an 'artistic malaria'. Her art challenged the status quo and was at once traditional and modern, often focusing on religious iconography but using abstracted techniques.

Mainie could have stayed on the continent where her work might have been more easily accepted, but she wanted to change the conservative view of art in Ireland and bring a Modernist approach to the artistic narrative of her country. Setting about this task with gusto, she taught, gave lectures and continued to show her work. Within a few years the *Irish Times* had changed its tune and she was recognised as 'the only serious exponent in this country of the ultra-modernist school of painting'. Later in her life, even after her own work had been accepted, Mainie continued to espouse rule breaking, co-founding the Irish Exhibition of Living Art, which championed unconventional Irish artists.

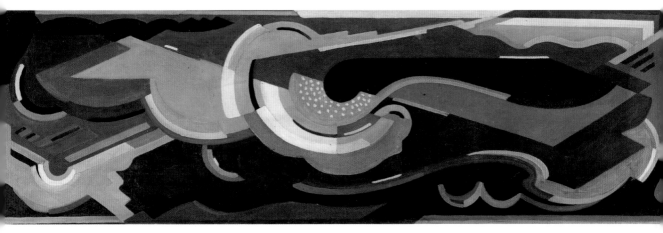

ABOVE: A Composition – Sea Rhythm, *Mainie Jellett, c.1926, 44 x 144 cm, oil on canvas*

What can we *learn* from Mainie?

1. Don't listen to criticism if you love your work. When you're breaking the rules, remember those who criticise from the outside are stuck back in time and they haven't caught up with you yet!

2. If you want to learn about something, pursue it with your whole heart. Knock on doors, ask questions, have an open mind. Mainie wanted to understand modern art and she sought out the best teachers to learn from, never taking no for an answer.

3. Just because a subject is traditional, it doesn't mean you can't treat it in a new way. Mainie took religious iconography and gave it a stunning modern twist. Conversely, a traditional approach applied to an unconventional subject can also produce interesting and challenging results.

Emily's reaction to Mainie Jellett

Mainie's work was so unusual for the time that she had to ignore the rules and forge her own path. This is an incredibly powerful story of a woman whose originality is so bold and honest and brave that it stops you in your tracks. You can feel the authenticity of her voice through her work. The message I take from Mainie is to ignore the world and paint exactly how and what you want.

Mainie has certainly inspired me to tear up the rule book. This piece is all about rhythm and colour. I've used a number of types of paint that would absolutely not be recommended but my gut wanted me to use particular colours from different sets of paints and have a mix of textures and varieties on the canvas. The reason you're 'not supposed to' use different paints together is that they can crack and do all sorts of unusual things. However, by ignoring this rule I've realised that the 'unusual things' that emerge add dimensions to my paintings that I've never seen before. This has broadened my painting horizons and lit a new spark in me, encouraging me to keep on experimenting.

RIGHT: Rhythm of Spring, *Emily Powell, 2021, 200 x 150 cm, mixed media on canvas*

Squares of joy

This is a great way of testing out breaking the rules and an opportunity to start learning about self-criticism. Being able to criticise yourself doesn't mean being negative, it means evaluating the consequences of the materials you've chosen and the marks you've made, working out what you like and what to take forward. This task can't be done wrong – it's all about breaking the rules!

1. Take a large piece of paper. If you don't have one, tape several smaller sheets together or try using a section from a roll of lining paper.

2. Tape the area into rough squares using masking tape or similar.

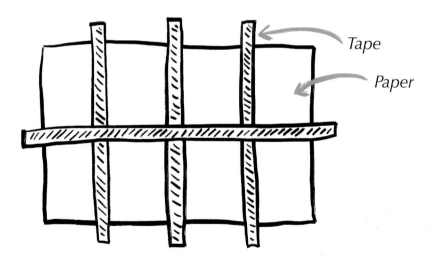

Tape

Paper

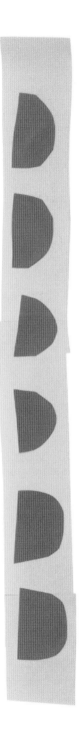

3. Think of a place you've got a strong connection with and pick up to four colours, each in a different medium, that represent how you feel when you think of that place. It's good to have a variety of media, both wet and dry, such as paints, pastels, crayons, pencils and felt-tip pens.

4. Paint, scribble, splash and spread your media all over the page, ignoring the taped lines and bursting out of and across the squares.

5. While you are making your marks, think about your place. For example, think about the sound of the birds you heard when you were there and make marks representing these, then move on to the feel of icy wind on your face.

6. Time for the bit we love – remove your tape from the paper – it might take a bit of the paper with it but don't worry, this is all about play and experimenting.

7. Write a title through the centre: 'Colours of x', where x is your place.

8. Now look at your squares all together – which is your favourite and why?

9. Look at the squares individually – what works in them? What best gives you a feeling of the place?

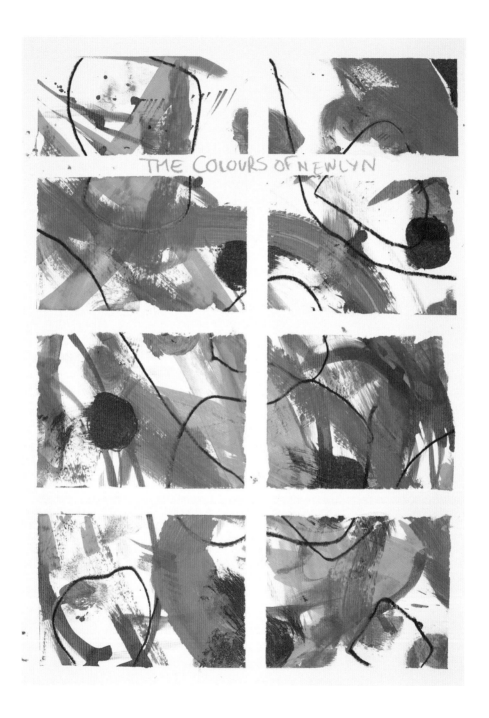

More, more, more!

Take what you've learnt from your first piece and make more, each time changing what you do based on what you've learnt from the last one and occasionally throwing in something totally unexpected. When you've finished, pick your favourite square and use it to inspire a full-scale abstract painting.

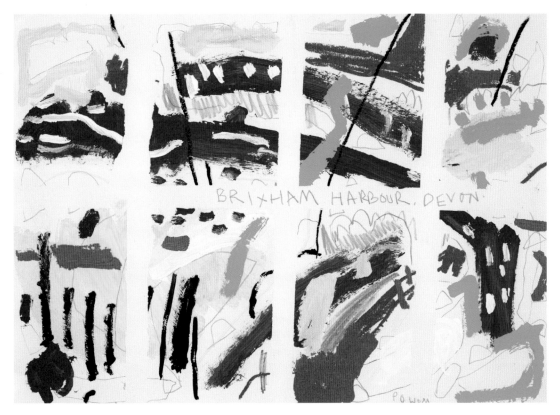

ABOVE: Emily's task
LEFT: Sarah's task
NEXT PAGE: Light Catching the Leaves, Emily Powell, 2020,
100 x 120 cm, mixed media on canvas

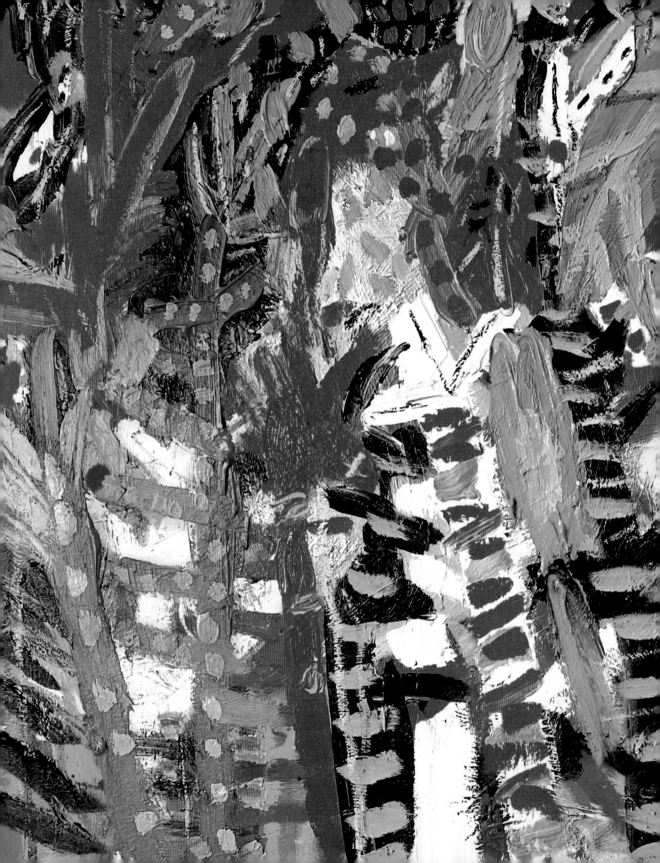

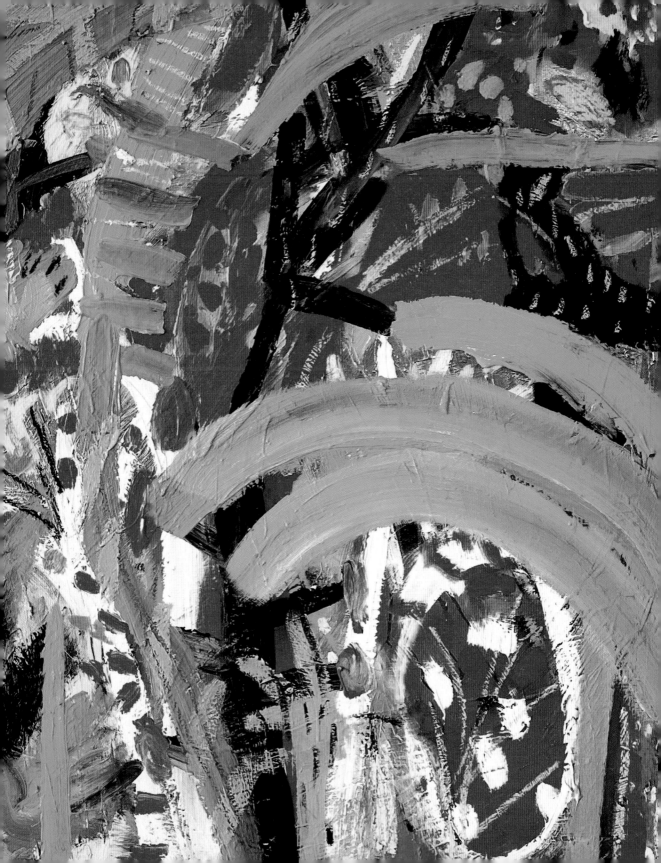

PART 2

Start now

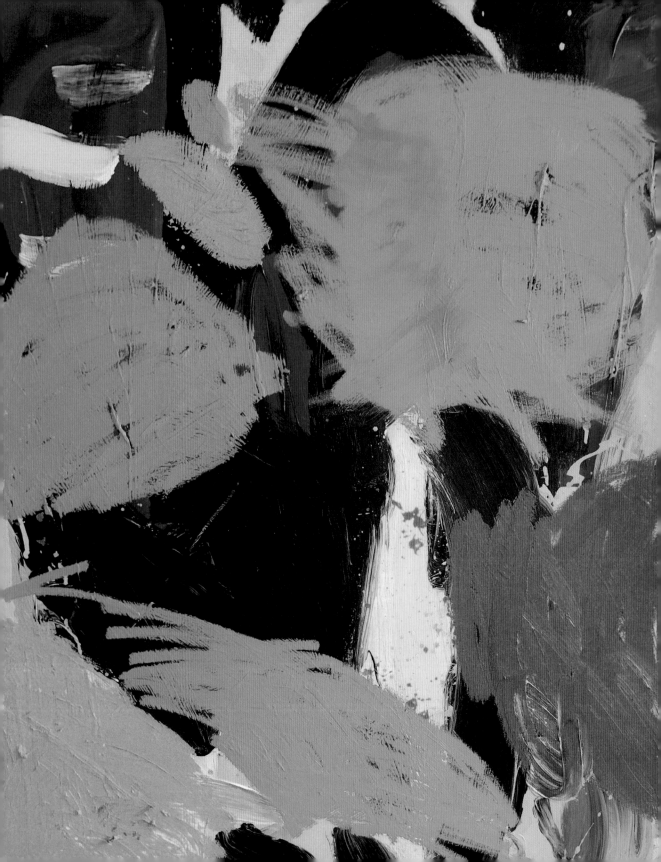

4. No more excuses

'You should keep on painting no matter how difficult it is, because this is all part of experience, and the more experience you have, the better it is . . . '

- Alice Neel

Take the plunge

How often have you made an *excuse* to yourself for why you couldn't be creative? If you're anything like us you'll be counting these on your toes in no time!

We promise that the joy painting brings is totally worth the effort of smashing through the excuses. This chapter explains why we make obstacles to getting started and offers tips and tricks to understand why we do this and how to overcome them in order to realise your creative potential. Maud Lewis provides an inspiring example of an artist who battled many adversities to create paintings filled with colour and life. Emily's joy-filled reaction to Maud Lewis provides impetus for you to complete our 'excuse buster' task. Then it's over to you to get painting, with no more excuses!

> *'You will have to experiment and try things out for yourself and you will not be sure of what you are doing. That's all right, you are feeling your way into the thing.'*
> - Emily Carr

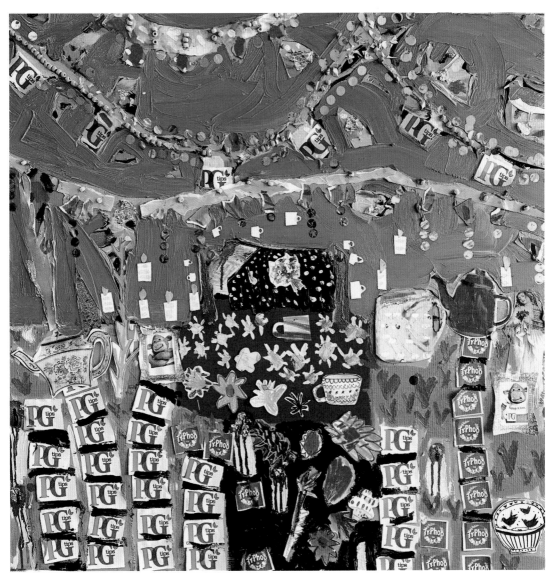

PREVIOUS PAGE: The Colour of Brixham Boats, *Emily Powell, 2019, 100 x 100 cm, oil on canvas*
ABOVE: Shrine to Tea, *Emily Powell, 2021, 100 x 100 cm, mixed media on canvas*

What's stopping you?

Excuses are real killjoys aren't they? They have a nasty habit of cropping up in all the most important aspects of our lives and they can have a huge effect on our ability to get things done. Since we have recognised the power of excuses to disrupt our creative process and worked together to move beyond them, we've found so much joy in painting. You've almost certainly overcome some excuses to get to the point of reading this book. Now we want to help you step even further outside your comfort zone. Just imagine what you could achieve if you channelled the creativity you put into making excuses into making art instead!

SOME OF THE EXCUSES THAT HAVE GOT IN THE WAY OF OUR PAINTING:

Sarah
– I should be working
– I haven't got the right brush/paint/paper
– I don't know what to paint

Emily
– I should tidy up instead
– I might put paint on the ceiling again
– The cat needs my attention

To be honest, whatever the situation happens to be, we are very good at turning it into an excuse to not get creative.

'The most difficult thing is the decision to act. The rest is merely tenacity.'

- Amelia Earhart

What's *wrong* **with excuses?**

Excuses are sneaky little things that get in the way of all sorts of important things in our lives. We want to focus on the effects that they can have on painting:

EXCUSES STOP US FROM

- reaching our potential
- learning through mistakes
- developing our own artistic style
- experiencing the joy of creativity
- playing without pressure

By interrogating the excuse and finding the underlying cause we've found we can often move past it and get on with our lives! It's worth persevering with this process, as it gets easier with practice.

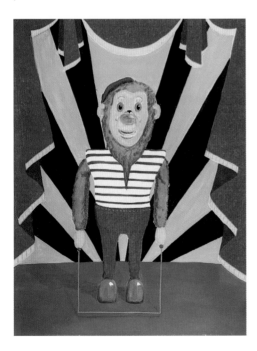

LEFT: Skipping Monkey, Sarah Moore, 2022, 22 x 30 cm, gouache on paper

TOP TIPS

Sarah – Don't beat yourself up for making excuses, make a conscious effort to be gentle with yourself. I find that if I ask myself 'What would I say to a friend in this situation?' I am usually much kinder to my friend than I am to myself!

Emily – Why not treat excuse-busting like a game? I love catching them out and feel great when I know they haven't got the better of me this time! For example:

Emily's heart: 'I want to paint!'

Emily's excuse factory: 'You have washing to do.'

Emily's heart: 'The washing can wait until later – good try!'

How can we *tackle* excuses?

Understanding why we make excuses has given us the ability to recognise them coming and to challenge them successfully when they get in the way of creativity.

Let us introduce you to fear and a cat, two of the key drivers for our personal excuses.

> *'I attribute my success to this – I never gave or took an excuse.'*
> - Florence Nightingale

The control cat

Excuses arise when we don't want to take responsibility for something, so instead we put the blame on something external to us. This has a fancy name – 'locus of control' – and can be internal where we are in charge and we make things happen, or external where we feel we aren't in control and things happen to us. One example we share is when our cats are sitting on our laps and we use it as an excuse to stay sitting on the sofa scrolling through our phones. Here the cat is the external controlling force stopping us from getting up and painting. If we shifted to an internal locus of control we would give the cat a cuddle then get up and go. The decision for what happens next has become ours and now we are in control, not the cat!

Over to you – We challenge you to fight back against the cat and take control – try our excuse buster task on page 92.

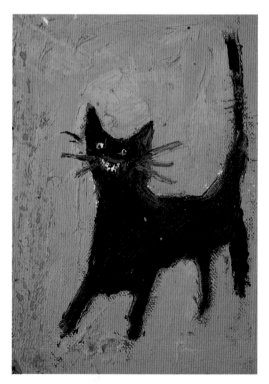

ABOVE: Cat With Teeth, *Emily Powell, 2018, 20 x 15 cm, oil on canvas*

Locus of control

Internal

'I make things happen'

VS

External

'Things happen to me'

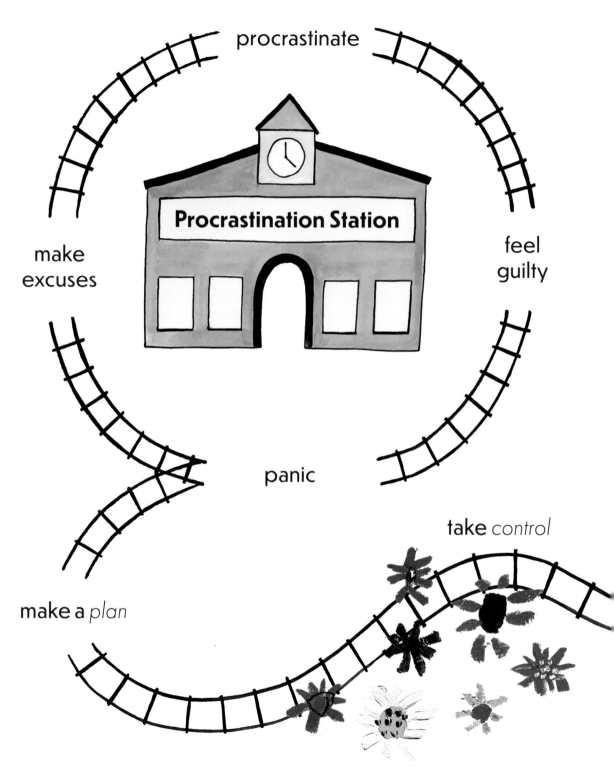

Sarah's confession – I am a perfectionist and master procrastinator and I've only just worked out that these two traits are intrinsically linked to one another. My procrastination occurs because I am terrified of failing to reach my perfectionist goals. I can be too worried to start because I can't decide on the perfect idea for a painting and then too terrified to finish in case the artwork doesn't match up to my unrealistic expectations. The stakes become raised on everything I do, then every painting becomes a story of success or failure measured against unrealistic external ideas or harsh internal standards. This makes the whole process a torture rather than a joy, and so I procrastinate and make excuses to avoid having to take action.

Fear of *failure*

We think the only way to fail at painting is not to do it at all! As soon as you get started you'll be learning and growing from all that you do. So why are we so afraid of failure? We've found that a useful trick for tackling things that scare us is to explore them in more detail so we can understand them. When you understand how a horror movie is made it becomes a lot less terrifying. So let's start by asking 'What is failure?'.

Definition of failure:

1. 'Not succeeding.'
2. 'Not doing something you are expected to do.'

These sound unappealing and scary, but what happens if we turn them around and think more carefully about what they really mean? Let's have a look at this on the next page.

Emily's top tips – When I'm doing something outside my comfort zone I set a timer for 20 minutes. I find knowing that I only have to do 20 minutes at a time means that I can get started. Once I'm going I usually become thoroughly engrossed in the process. Why not try this if you're feeling painting is outside your comfort zone?

My top tip for perfectionists like Sarah when they are painting is to start by defining success as enjoyment of the process. You'll be amazed how easily the art flows from that simple change in your approach.

ABOVE: Still Life With Bears, *Sarah Moore, 2021, 100 x 100 cm, mixed media on canvas*

Q: What is success anyway?
A: Whatever *you* decide it is!

In a maths exam you can measure scores precisely and objectively; there is a right and a wrong answer. Art, however, is subjective, based on personal feelings, tastes and opinions. Therefore you have the power to reframe 'success'. You could define it as painting for half an hour once a week or perhaps visiting an art exhibition. You might think photorealism is impressive or you might be blown away by an abstract painting. The wonderful thing to realise is that it is up to you to decide.

Q: Why is it a failure not to
do what is expected of us?
A: It's not!

Not doing what you are expected to do is actually a really liberating experience. If we always do what is expected of us, we miss out on the joy of experimentation. Have a think about what is expected from you and try doing something different for a change – throw paint at a large canvas, or paint in miniature. You'll find that this process of experimentation frees you to develop and grow in a way that could never be achieved by behaving and sticking to what is expected of you.

For us this approach really helped us to understand failure not as something to be feared but as a wonderful opportunity to produce unexpected results that challenge and excite us. It's time to embrace the joy of the process and let go of our fear. No more excuses!

Maud Lewis
1903–1970

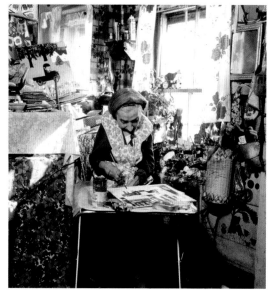

ABOVE: Maud Lewis painting in her home in Nova Scotia, 1965
OPPOSITE: Coastal Scene with Gulls, Maud Lewis, 1960s, 30.5 x 34.5 cm, oil over graphite on particleboard

'I paint all from memory, I don't copy much. Because I don't go nowhere, I just make my own designs up.'

- Maud Lewis

Maud Lewis painted a world without shadows. Using paint straight from the tube she created lively scenes drawn from her imagination and experience. Maud painted everything she could lay her hands on. The surfaces of her tiny rural house in Nova Scotia were soon covered in her bright, illustrative paintings. Passing motorists would stop to admire the house and to buy paintings for $5 a piece. This paid for paint and equipment to sustain her prolific outpouring of work. Now her paintings and even her little house are preserved in galleries and museums.

In contrast to the bright images she painted, Maud's life was tough. With no formal training and limited education she lived in a tiny one-room house. Her husband was a difficult character and Maud was troubled by crippling rheumatoid arthritis from a young age. This left her unable to use her right hand properly, but she would support it with her left in order to continue painting. The creation of her work was a painstaking process but it was vital for her self-expression, and this light, life and colour surrounded her in her home every day.

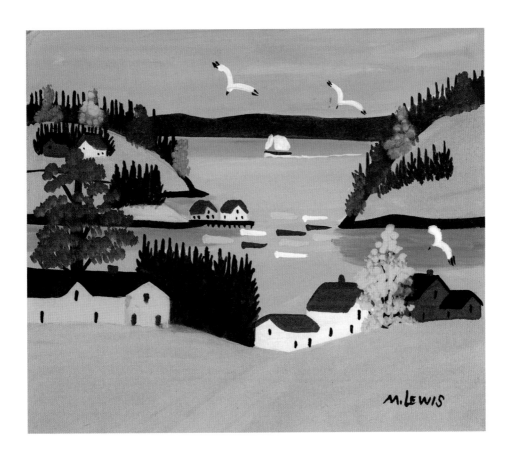

What can we *learn* from Maud?

1. Whatever your circumstances, find a way to get started and you'll be amazed at where you can end up.

2. Don't be afraid to just paint and paint and paint. The more you do, the more you learn, not just about technique but about who you are as an artist.

3. Surround yourself with your work – pin it up on a wall, or paint the wall! This process can be extremely rewarding, giving you the opportunity to understand your work and think about what you might do next.

Emily's reaction to Maud Lewis

I love Maud Lewis's work and I have been really inspired by her story. It made me realise how important it is to surround myself with my work and to share it with the world.

One summer I decided to brighten up the town and create my own version of a painted house. Unfortunately, mine had to be temporary as the house was rented, but that didn't stop me. The response from the locals was wonderful and I got to know many more of my neighbours. People would stop to tell me how happy my art had made them feel and that filled me right up with joy!

'If I've got a brush in front of me I'm alright.'

- Maud Lewis

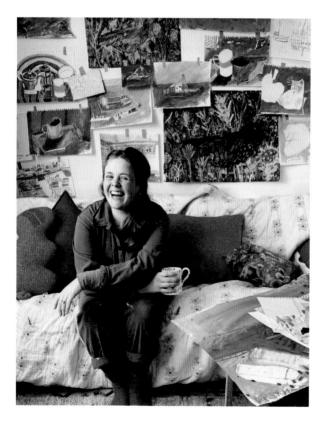

LEFT: *Emily in her studio, 2020*
OPPOSITE: *Emily's house in Brixham, 2020*

When I started out painting full time I didn't have a studio so I just made the best of what I had. I was renting a small terraced house and I took over the whole ground floor. By necessity I was surrounded by my art and I realised that having my work on display really helps me to see how I am progressing and understand where to go next. When you live fully immersed in your work there are no excuses!

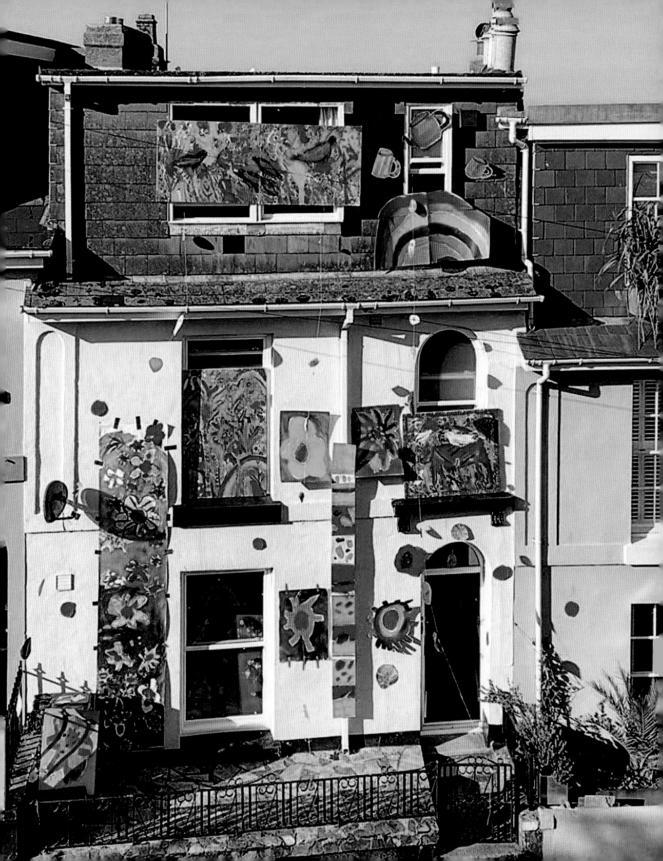

Excuse buster

This might be a difficult one but we promise it will be worth it.

1. Treat yourself to a bit of alone time, even if it is just 5 minutes to start with, you can keep coming back to this task.

2. Sit yourself down with a pen and paper.

3. Fold the paper in half.

4. On one side of the paper write a heading 'My excuses'.

5. Underneath this write a list of all the excuses you make for not painting or making art.

6. Keep going – be really honest with yourself.

7. On the opposite side of the paper write a heading 'My solutions'.

8. Under this heading write down solutions for getting around these excuses.

9. Pin this list up somewhere that you will see it regularly – on the bathroom door, the fridge, your mirror.

10. Practise your strategies for overcoming your excuses.

MY EXCUSES

☆ Do the dishwasher it needs to be done

☆ Go on a walk, keep fit.

☆ I can't find the time

☆ I don't have space

☆ I don't have the right materials.

MY SOLUTIONS.

☆ I'll fill my soul with art first then I'll do the dishwasher with a bounce in my step.

☆ do both walk and take sketchbook.

☆ manage your time better get rid of some negative stuff.

☆ either make space, work small or work outside in sketchbook

☆ use different materials, stop being a diva

MY EXCUSES

· I don't have time

· I don't know what to paint

· I should be working

· I need to walk the dog

· I'm too tired

MY SOLUTIONS

→ dedicate a specific time – plan ahead

→ look at your inspiration collector + saved photos

→ you work better if you are relaxed – set aside time for both

→ use it as time to get inspired – look at the sky and the trees

→ painting re-invigorates you – try just 30 mins to start with

More, more, more!

If you're feeling really brave, why not ask those nearest and dearest to you to be honest with you about the excuses they see you making? Do they fit with your list? Now address their suggestions by working through this exercise again and discuss the results. This outside perspective can really extend your learning and is a great tip for any exercise – seek out a person whose opinion you value and get them to extend your understanding.

5. Inspiration

'Everything I do adds up and goes into the art of painting.'

- Corita Kent

Inhaling ideas

We love to think of *inspiration* **as the inhalation of ideas so that we can exhale art.**

In this chapter we take you on a whistle-stop tour of where to find these ideas and how they might influence your art. Along the way you'll be introduced to your inner magpie and we will explore our own experiences of inspiration. Fahrelnissa Zeid provides a fabulous role model and illustration of the varied sources of inspiration one artist might have. Emily shares her reactions to Fahrelnissa and to an inspiring object, showing you how it popped up in her paintings. Finally, it's over to you to have a go at creating your own book of ideas – don't worry, there are fail-proof instructions! You'll be amazed at just how much inspiration surrounds us every day and how satisfying it feels to open your mind and breathe in those ideas.

For us, inspiration is all about inhaling ideas so they can rattle around in our creative brains and then be expressed through the lens of our own experience as art. The more ideas we can inhale, the more opportunity they have to bump up against each other, to develop and evolve. These ideas don't need to come from exotic holidays or trips to museums, they can come from a walk in the park or a picture in a magazine. Wherever your inspiration comes from, the key to being able to capture it and recognise its value is being open to new ideas. Let's start by introducing you to your inner magpie.

PREVIOUS PAGE: Boats on a Tuesday, *Emily Powell, 2020, 100 x 100 cm, oil on canvas*

> *'Art is the concrete representation of our most subtle feelings.'*
>
> *- Agnes Martin*

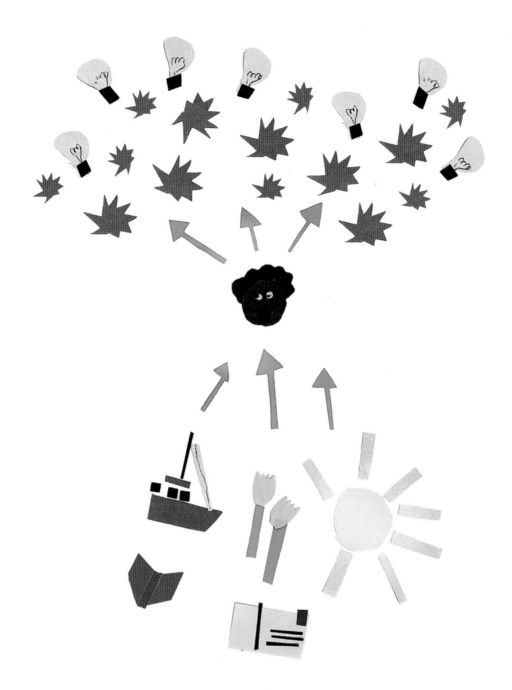

The more you put *in*, the more you get *out*.

Meet *your* **inner magpie**

We like to think of our creative brains as hungry magpies, eager to be fed with inspiration. As each of us travels through life our magpie keeps an eye out for interesting ideas and stores them away in its 'box of shiny things'. Some ideas come fully formed, whilst others meet up inside the box and create new ideas of their own. Some ideas sit in a dusty corner for years until you need them, while others jump up and down shouting 'ME ME ME!' so you can't ignore them. On some days the clamour of ideas wanting to get out is deafening and they burst out of us through painting, singing, drawing or dancing. Other days are quieter and we have time to dig through the box and explore the ideas that require more thought.

We want to help you train your magpie to spot shiny ideas. The more you feed and care for it, the easier it will become to reach for inspiration. These ideas don't have to be extraordinary in any way for them to be attractive to the magpie. You might take your magpie to a gallery to look at works of art but you equally might invite it to look at the rain running down your window. What is important is that the magpie is alert to the potential for inspiration and trained to keep its eyes open. Sometimes your magpie will be hyper alert and other times it will be fast asleep, usually when all your energy is being diverted to the rest of your brain. Nobody wants their magpie working 24/7 but we thoroughly recommend training it up so that it works more efficiently and effectively for you. Why not try our task on pp. 108–109?

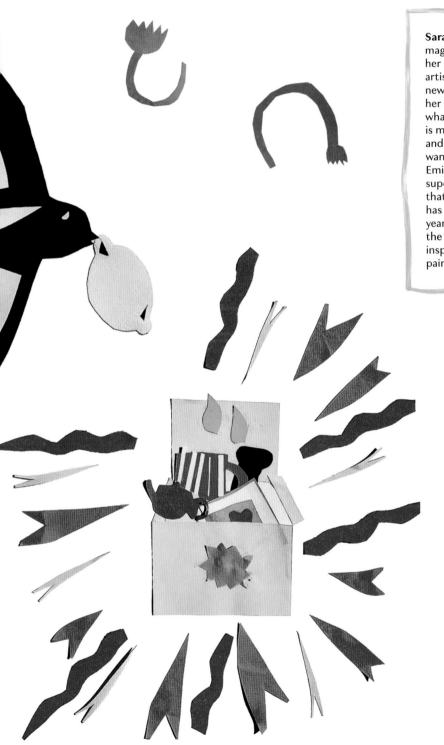

Emily – I went with Dad to the Royal Academy in London to see a painting called Flaming June by Frederic Leighton. The painting was wonderful, flooded with colour and energy, but that's not what I remember most. What remains most vividly was Dad's passion for the painting and the joy he took in seeing this work in real life. Dad was inspired by the painting and I was inspired by his love of art. I realised that people can inspire us just as much as art and that love of art has never left me.

Sarah – I was nine years old, sitting on the floor of the Walker Art gallery in Liverpool, looking up at the magnificent Whistlejacket, a painting of a rearing horse by George Stubbs. I sat cross-legged on the floor in front of it for hours, looking at the details and trying to copy them into my tiny sketchbook. I was completely oblivious to time and curious onlookers, lost in the joy of the moment. I still have this drawing in my studio as a reminder of this feeling.

Over to you – What is your first memory of being inspired by art? Have a think about how it made you feel. What do you think you could do to capture that feeling again?

Sources of inspiration

Some of our favourite sources of inspiration are other artists, which is why we are so keen to share an artist with you in each chapter of this book. We also thoroughly recommend getting out there to museums, galleries and sculpture parks to look at art in real life. This experience can't be beaten, as it is so difficult to get the scale, colour and texture of a painting on a screen or in a book. However, if you can't get to museums and galleries, there are amazing treasures to be found online. We often draw objects together from the fabulous treasure trove of the V&A museum collection, which is available free online. However, our inspiration is certainly not confined to other artists or museums and galleries.

We draw much of our inspiration from everyday life. This might be a beautiful lemon bought from the local grocers or a reflection in a puddle that we spotted on our way to the shops. Sometimes our inspiration isn't an object, instead it's a feeling that drives our creative work. This might be the quiet calm of sitting in an armchair with a cup of tea or the joy-filled freedom of freewheeling downhill on our bikes. By combining what we see and feel, we are able to communicate our own unique vision of the world around us.

Emily – I live by the sea and have gulls flying past my window every day. They always find a way to sneak into my paintings!

Sarah – I love being outside in the wind. I feel the raw power of it and I feel alive. It's this feeling that I try to capture in abstract paintings.

'When you take a flower in your hand and really look at it, it's your world for the moment. I want to give that world to someone else.'

- Georgia O'Keeffe

OPPOSITE: Sarah's drawing of Whistlejacket from when she was 9. RIGHT: Our paintings inspired by the V&A collection. From the top, Emily, Sarah, Sarah, Emily.

Role models

Role models are people that inspire us and we've found them to be really important in our lives. They don't need to be famous professional artists – or even painters – to be inspiring. They might be a single mum who sits down with her kids at the kitchen table every Saturday morning and draws with them. Or they could be someone who decided to go to art school later in life, after their kids had left home or after retiring from work.

Your role models might not even paint. They could be an old friend who has started learning the piano and practises for an hour every night, or a neighbour that generously shares the results of their love of baking! We aren't suggesting you try to be exactly the same as another person, instead it's about recognising different role models with varied attributes that you value and that you'd like to build into your art practice and your life. Why not start a role model collection now?

Don't forget that just as those around you can fill you with inspiration, you might be a role model for others too! Like us, you might have grown up in a world that expects you to be modest and self-deprecating, but there is a lot to be said for recognising your strengths and sharing them with others. To be told that another person looks up to you as a role model can be a surprise at first but it is a true honour and often more fulfilling than any prize or award.

Look around you and we bet not only that you can identify strong role models, but that you are also a role model to others, even if you don't know it!

> OPPOSITE: Detail from March Onwards, Emily Powell, 2019, 150 x 120 cm, oil on canvas

WHAT WE NEVER WOULD HAVE ADMITTED WHEN WE WERE YOUNGER: WE FIND EACH OTHER INSPIRING

> **Sarah** – Emily inspires me with her courage to have a go. Under her influence I let go of my worries about getting things 'right' and before I know it I'm in my happy place, playing with paint.

> **Emily** – I find Sarah's drive to understand and emotionally connect with other artists inspiring. She'll say 'Have you seen this artist?' and almost before she's finished showing me I'm off painting...

> **Over to you** – Who inspires you and why? Why not tell them?

'I think the best role models for women are people who are fruitfully and confidently themselves, who bring light into the world.'

- Meryl Streep

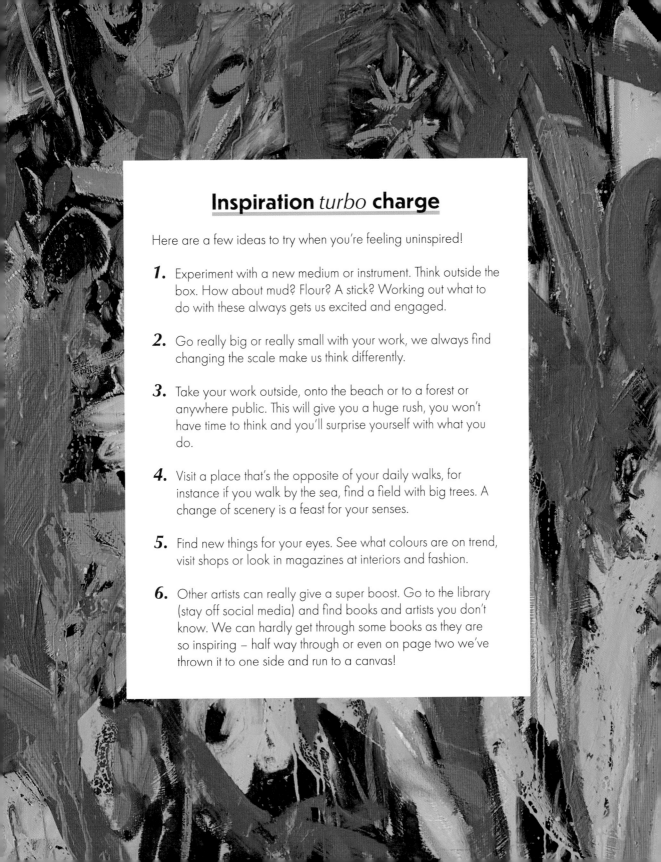

Inspiration *turbo* **charge**

Here are a few ideas to try when you're feeling uninspired!

1. Experiment with a new medium or instrument. Think outside the box. How about mud? Flour? A stick? Working out what to do with these always gets us excited and engaged.

2. Go really big or really small with your work, we always find changing the scale make us think differently.

3. Take your work outside, onto the beach or to a forest or anywhere public. This will give you a huge rush, you won't have time to think and you'll surprise yourself with what you do.

4. Visit a place that's the opposite of your daily walks, for instance if you walk by the sea, find a field with big trees. A change of scenery is a feast for your senses.

5. Find new things for your eyes. See what colours are on trend, visit shops or look in magazines at interiors and fashion.

6. Other artists can really give a super boost. Go to the library (stay off social media) and find books and artists you don't know. We can hardly get through some books as they are so inspiring – half way through or even on page two we've thrown it to one side and run to a canvas!

Fahrelnissa Zeid
1901–1991

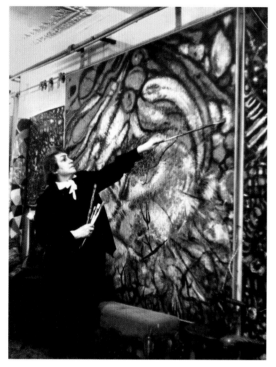

▌ ABOVE: Fahrelnissa Zeid in her studio, Paris, 1950s

Fahrelnissa Zeid took inspiration from all that surrounded her, no matter how grand or mundane. A trip by aeroplane or a fly on the wall, the museums of Europe or a turkey bone. Fahrelnissa took great interest in the world around her and these influences emerged in her paintings. Soon after a dear friend passed away, Fahrelnissa was sitting in her studio and saw a fly moving around on the wall. She immediately wanted to use these movements in a canvas as she felt at that moment that they represented life itself. Her monumental five-metre-long canvas *My Hell* was inspired by this simple observation.

Fahrelnissa's early life was one of wealth and prosperity, descended from Turkish royalty and married into the Iraqi royal family. Later in life, however, her family fell on hard times and she learnt to cook for the first time. It was as she went to discard the bones of a turkey that she noticed their shape and beauty. She rescued the carcass, painted it and presented it to the French Minister for Culture!

Fahrelnissa also became an inspiration to others, gathering a group of women with no artistic training in the conservative culture of Amman, Jordan. She inspired these women to create their own abstract art whilst at the same time finding herself inspired to move into portraiture.

'You must forget what you know because what you know is what you have learned, but what you do not know is what you really are.'
- Fahrelnissa Zeid

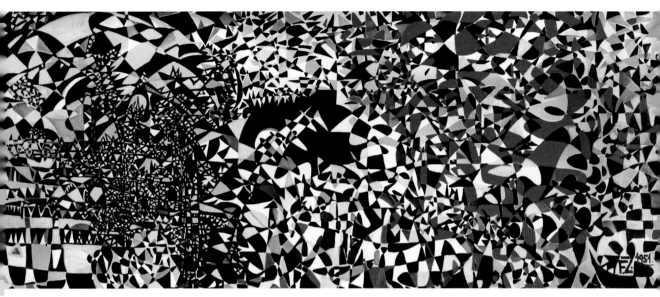

▌ ABOVE: My Hell, Fahrelnissa Zeid, 1951, 205 x 528 cm, oil on canvas

What can we *learn* from Fahrelnissa?

1. Inspiration can be found in the strangest of places. Keep an open mind and a curious approach to the world and you'll be constantly amazed by what you find.

2. You might not be conscious of your sources of inspiration whilst you are working but that's ok, you'll be surprised what influences you see when you step back and think about your work.

3. Sharing your experience with others can be inspiring in itself and can set you off in a whole new direction.

Emily's reaction to Fahrelnissa Zeid

I find Fahrelnissa's absolute dedication to art through experimentation so energizing. In the end she was her work, it was almost like breathing to her. That's what I love, painting becoming so instinctual it's no longer a head thing, it's all about gut and heart. Painting was how she navigated feelings and life, and I completely understand that.

Like Fahrelnissa, I get my inspiration from lots of different places. One thing I absolutely adore is a good source of natural world illustrations. In fact, for my last birthday that's what I asked for from Sarah! My favourite of these has to be a small leaflet of British birds that used to belong to my dad. When I first got it handed down to me, my work suddenly developed birds all over the place and they still make frequent appearances now. In the year since it arrived, it's fallen apart, been covered in paint, been laminated and fallen apart again, but it still brings me joy and is my go-to source for bird-shaped inspiration!

'Often, I am aware of what I have painted only when the canvas is at last finished.'

- Fahrelnissa Zeid

 ABOVE: Emily's bird leaflet

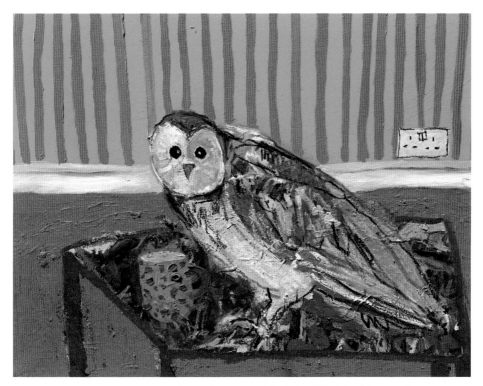

THIS PAGE: Clockwise from Top: Owl at Home, Emily Powell, 2018, 45 x 80 cm, mixed media on canvas; What a Night, Emily Powell, 2018, 100 x 180 cm, mixed media on canvas; Thinking Bird, Emily Powell, 2018, 70 x 100 cm, mixed media on canvas

Magpie training school

This task is about gathering together visual items you find attractive and in the process developing your own resources for inspiration. We like to carry our little sketchbooks round with us and stick in anything we find that makes us excited, such as a good napkin from a cafe or a ticket from an exhibition, and especially a good old paint chart. We've found developing our collections gives us a really strong sense of self, of what brings us joy and of how our visual brains work.

First, follow our simple step-by-step guide to making your own sketchbook (though feel free to use a different book-making technique or shop-bought sketchbook if you prefer).

1. Take a piece of paper – this can be any size and any colour, new or recycled.

2. Fold it in half down the centre, lengthways, to get a long thin rectangle.

3. Fold it in half the other way.

4. Fold each end into the middle.

5. Write your name on it. This is super important as this is a visual diary of who you are!

Now it's time to get cutting and snipping and gluing and sticking. In case you're not sure where to start we've put together a list of ideas to help you get going, but there's no need to use these. Remember, this isn't about being neat or ordered and there is no right or wrong. Just stick in everything that lights up your life, we promise you'll love it and it's 1000% worth it!

1. Find an old magazine, newspaper or leaflet and cut out things you find attractive. Just go with what your gut likes, whether that's a great-shaped kettle or a wild pair of patterned trousers, stick them in.

2. Stick in postcards of art you adore. Around these scribble down what you think has drawn you to them.

3. Get a paint chart or a pile of paint swatches and cut out all the colours you love, don't worry about what order you put them in. You might get exciting surprises seeing what they look like next to each other.

4. Experiment with patterns, there are patterns everywhere in day-to-day life, draw them in, fill every space with them.

5. Layer up, don't worry about the order you put things in your sketchbook, just go with the flow. Sticky tape can be your friend here for making flaps or adding pages.

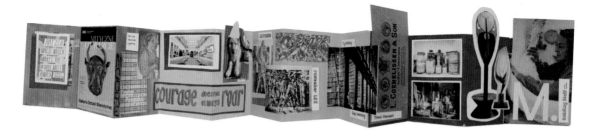

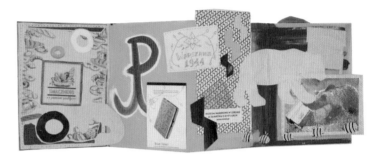

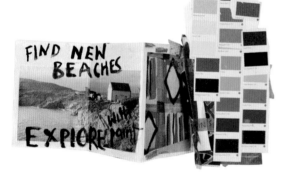

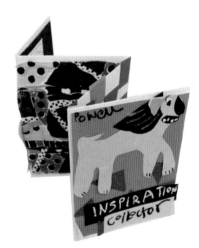

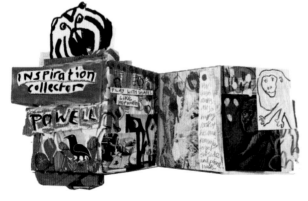

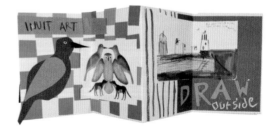

ABOVE: Our sketchbooks inspired by this task. Clockwise from the top: Sarah, Sarah, Emily, Emily, Emily, Emily, Sarah.

More, more, more!

If you fancy expanding your repertoire, here is another sketchbook design for you to try:

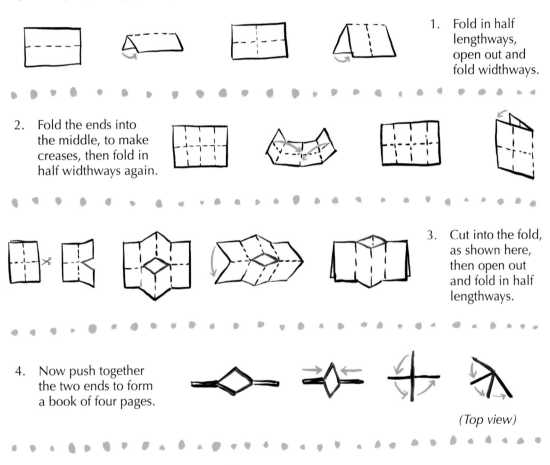

1. Fold in half lengthways, open out and fold widthways.

2. Fold the ends into the middle, to make creases, then fold in half widthways again.

3. Cut into the fold, as shown here, then open out and fold in half lengthways.

4. Now push together the two ends to form a book of four pages.

(Top view)

(Side view of step 4)

5. Voila – another book! (p.s. don't forget to write your name on it!)

Now it's over to you. Make as many as you like. Take them everywhere. You'll suddenly find inspiration wherever you look. Not only will they inform your painting but they'll give you a strong sense of self. Think of your sketchbook as a pocket 'you'.

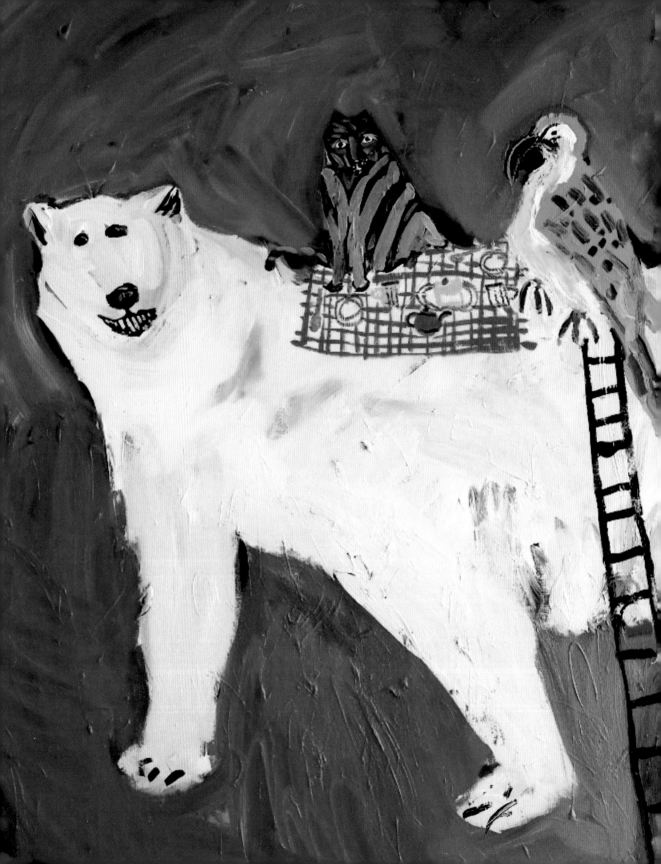

6. Tell your story

*'Art is not always about pretty things.
It's about who we are, what happened
to us and how our lives are affected.'*

- Elizabeth Broun

Your authentic voice

How often have you stopped and thought about how *unique* and interesting you are?

If you're anything like us, the answer is likely to be never! This chapter is your chance to do just that. We want you to get to the end of this section with the knowledge that your story is important and the courage to tell it with your own authentic voice. Underpinning this is an introduction to vulnerability and how the courage to show our true selves can enhance our lives.

We will introduce you to Faith Ringgold, whose artistic practice has been defined by telling her story. Then we show you examples of Emily's storytelling. We finish with a task, which is a portrait of your very own spirit tiger!

'There's power in allowing yourself to be known and heard, in owning your unique story, in using your authentic voice.'
— Michelle Obama

PREVIOUS PAGE: *Detail from Polar Bear, Parrot and Cat: The Picnic, Emily Powell, 2020, 100 x 180 cm, oil on canvas*
OPPOSITE: *Wonderful, Emily Powell, 2021, 30 x 42 cm, collaged paper*

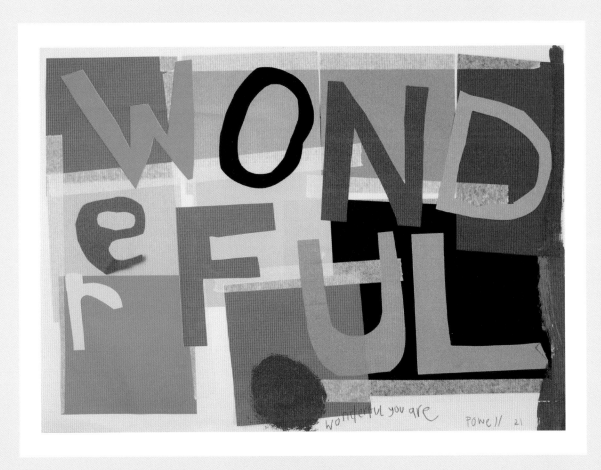

wonderful you are POWell 21

Your story *matters*

We want you to know and to truly believe that your stories and viewpoints are valid and important. Nobody else will have the same experiences as you and nobody else could create the art that you do. The key to believing this lies in understanding that you are worthy of love and belonging. In order to achieve this we have to learn to be vulnerable, to show our true selves and be accepted for who we are.

Our world is full of incredible stories – and yours is one of them. A full and rich history of our world is one that combines the stories of everyone. For thousands of years, history has literally been **HIS STORY**, written and owned by privileged white men. That narrative is not unimportant but it is not the only story that needs sharing. By recounting all of our stories through art, we can add to the breadth and depth of available perspectives. This doesn't mean we have to tell exotic or exciting stories. We just have to show up and tell the story of our own lives.

We find that our best work is done when we paint from our own experience. That doesn't mean your work has to be a photographic representation of what you see around you. The joy of painting is that you don't have to paint exactly what is in front of you. You paint how you see it.

'Owning our story and loving ourselves through that process is the bravest thing we'll ever do.'

- Brené Brown

Every nuance in our lives affects how we paint – and that's the joy of it! Here are some things that affect how we paint:

- Is it a new experience or one layered with memories?

- Are we having a good day?

- When did we last have a cup of tea?

- What's the weather doing?

- Are we painting on location or in the studio?

- What are we listening to while we paint?

We love holding workshops because we get to see how differently people interpret the same set of instructions and the same set of materials. Each person's experiences and emotions form layers that make their work unique. Why not try painting with a friend – follow the same set of instructions and see how different your results are!

ABOVE: Elephant Book, Sarah Moore, 2021, 15 x 21 cm, mixed media on paper

Emily – When I truly let go and decided to paint what I saw and felt instead of what I thought people wanted me to see and feel, a whole new chapter opened for me. I didn't worry about outside points of view, only my own. I realised my way of seeing things was completely unique to me and I started to really enjoy every outcome and process, however unusual the result. I found being completely honest with the paint terrifying but the payoff far outweighed the risk. I feel there's huge empowerment to be found when you are honest with your art materials. If I'm feeling bold I'll paint bold. If I'm missing whimsy in the world, I'll paint whimsy into it.

Sarah – When I started my year-long art course, I would never have dreamed of telling my story. I hid behind the tales of others, researching other artists in depth and sticking to established narratives that only skimmed the surface of my true self. However, by the end of the year I had the confidence to tell my own story, a story of my childhood and my relationship with our dad, who died when we were young. I had never really talked about it and was terrified of putting it on display, but I did – and I was absolutely amazed at the results. I had made this art for me, to celebrate the happy times we had enjoyed together, but so many other people connected with it on lots of levels. Only looking back now do I realise it was the best work I produced because I had used my voice to tell my story.

Vulnerability

This is a really tricky one. Showing vulnerability can be a difficult and sometimes even excruciating experience but we promise the risk is worth the reward! Stick with us as we explain why you'll be glad you have given it a go.

Along our creative journeys we've both discovered that, in order to tell our personal stories in our authentic voices, we have to be willing to be vulnerable. We have to open up and put our true selves on display. Every time we paint something, we are putting a piece of ourselves out on the canvas, and that can feel very exposing. Vulnerability feels risky and uncertain and we feel emotionally laid bare but without it we don't get to be ourselves. It's like the old adage about being scared to love in case you get hurt. The hurt can be terrible but what would our lives be without love? Putting yourself out there and telling your story can be scary and difficult but ultimately we've been amazed at how rewarding it can be.

One of the reasons we both struggled for so long with vulnerability is that we were confusing it with weakness. However, we want you to know: **vulnerability is not weakness.** In her book *Daring Greatly*, researcher and author Brené Brown sums this up perfectly when she says 'Vulnerability sounds like truth and feels like courage. Truth and courage aren't always comfortable but they're never weakness.'

Sarah's top tip – If you want to learn more about the fundamental importance to our creative selves of understanding shame and vulnerability, I thoroughly recommend you look at the work of researcher, author and speaker Brené Brown, whose online talks and books have taught me so much.

OPPOSITE: Beautiful Vulnerability, *Sarah Moore, 2022, 30 x 42 cm, gouache on paper*

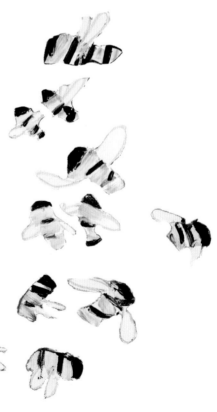

what makes you **VULNERABLE** makes you **BEAUTIFUL**

— BRENÉ BROWN

Share your highs and lows

We are by no means vulnerable all the time and we don't recommend you diving in feet first either, but we do challenge you to take some time to think about how this might be affecting your creative work and to start dipping a toe in the water to see what reaction you get.

Choose people you care about to be vulnerable with and listen to their responses. Whenever we get overwhelmed by this we each think of our closest friend and how we feel when they share something with us that is important to them. We want to celebrate their successes and moments of joy and are kind and understanding when they are in difficulty. Why should their reaction to us sharing something with them be any different?

Writing about vulnerability is all well and good but we also need to walk the walk. We totally appreciate how difficult this is and have both struggled with it in our different ways:

Why not see how much overlap you can acheive?!

Sarah – I've been carefully trained not to show my feelings, not to share my story and not to be vulnerable. Doctors are expected to be invulnerable; unaffected by our own day-to-day worries and concerns, never mind the traumatic, distressing situations witnessed as part of our work. This certainly has a place in our professional lives but it can be very detrimental to our own mental health if we extend it into our personal lives. It's taken me a very long time to realise how important vulnerability is and that it does not equal weakness. I am sure that many of you reading this book will recognise my story, whether it be through your profession, your upbringing or the way society has shaped you. To you I want to say that it is possible to change and that the rewards that can be achieved really are worth the difficulty of the process.

Emily – I've always found using numbers and words a difficult way to express myself. They float around in my head with no real meaning and I've found this incredibly frustrating. Not being able to use words and numbers effectively made me feel unheard. Colour and paint gave me what I needed to communicate with the world around me. Being able to finally tell my story through paint and colour has really changed my life for the better. I feel being able to express my true self is the most powerful thing I have.

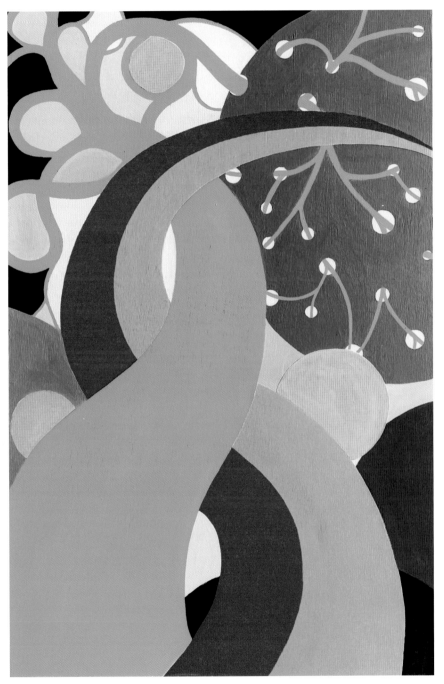

ABOVE: Grounded, Sarah Moore, 2021, 40 x 60 cm, acrylic on wood

Faith Ringgold
1930–

ABOVE: Faith Ringgold in her studio with a print of Woman Looking in a Mirror, 2022
OPPOSITE: Tar Beach #2 2/5 AP, Faith Ringgold, 1990–92, 167.6 x 167.6 cm, silkscreen on silk with pieced fabric border

Faith Ringgold doesn't need anybody to tell her story for her, she has made it her life's work to tell it herself through art. Faith grew up surrounded by love and creativity during the Harlem Renaissance in the 1930s. At City College of New York she discovered that women were not permitted to study art, so she studied art education instead. Her training was very much influenced by the European style and she emerged from college painting still lifes and landscapes with no connection to her environment. Modern art at the time was pure abstraction and neither of these methods spoke to her experience of life.

Realising that 'it's the 1960s, all hell is breaking loose all over', Faith painted her groundbreaking *American People* series, where she depicted her experiences as a black woman in America. This version of events was absent from the news stories and abstracted visual art of the time. Later, Faith moved to painting on fabric to make into quilts, a 'visual art form of my ancestry', which spoke to the generations of women in her family who had created art through this medium. In these she uses words and pictures to tell stories such as the autobiographical *Tar Beach*, the story of a girl who lies up on the roof of her apartment block dreaming of a world where she can fly, defying the rules and being whoever she wants to be. Which is exactly what Faith has achieved.

'You can't sit around waiting for somebody else to say who you are. You need to write it and paint it and do it. That's where the art comes from. It's a visual image of who you are. That's the power of being an artist.'

- Faith Ringgold

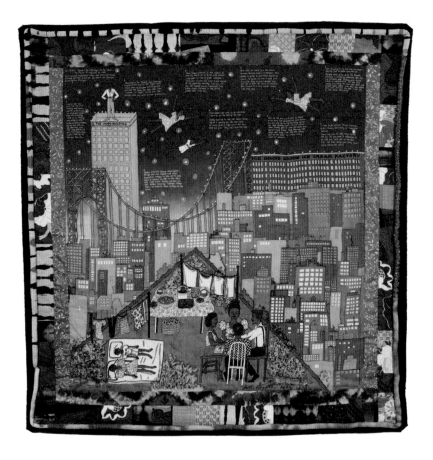

What can we *learn* from Faith?

1. You are unique and your story is important. Don't listen to anybody who tries to tell you otherwise. Paint your life exactly the way you see and feel it.

2. You can paint on anything – fabric, walls, canvas. Anything that allows you to fully express yourself.

3. You don't need to go to life drawing classes for years or learn to draw the 'perfect' orange: you can just draw people and objects exactly how they come out of your brush. There is no right or wrong way.

Emily's reaction to Faith Ringgold

I absolutely loved Faith Ringgold's work as soon as I saw it. Her figurative art is very freeing and doesn't have those anxious boundaries that are found in other works. Her authenticity radiates from the painting in such a way that I couldn't help but feel heartened by her art. Every detail is unapologetically itself and she celebrates this way of painting. After experiencing her work I suddenly felt things lose gravity. Things and people began to float and fly as my work lost the constraints of reality.

'I was trying to find my voice, talking to myself through my art.'

- Faith Ringgold

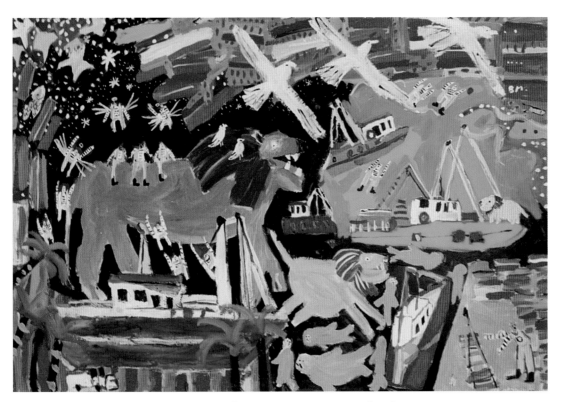

ABOVE: A Proud and Fierce Town, *Emily Powell, 2020, 180 x 230 cm, mixed media*

Meet your spirit tiger

This task is all about letting go of who you think you are and discovering who you really are . . . or at least, who your spirit tiger is!

1. Get yourself a work surface – paper/canvas/card, anything will do.

2. Choose a pale but bright colour you love and paint your surface all over with it.

3. Now, while that is drying, have a think about you and your spirit tiger. This is not about how you and your tiger *should* be, it is about how *you are*, your true self right now.

 - How does it feel?

 - What is it doing?

 - Where is it?

 - What size is it on the surface?

 - Are there any important things it needs nearby?

4. Time to pick your colours – we recommend you forget reality and choose the colours that speak to you right now. Start with four colours and you can always add more later.

5. Now it's over to you, we aren't going to tell you how to do the next bit because it is absolutely up to you, this is between you and your tiger.

Your tiger will be constantly changing, depending on how you feel and what is happening in your life, so this is a great exercise to revisit over and over again – we have been surprised at how our tigers have told us how we are feeling when we didn't know ourselves!

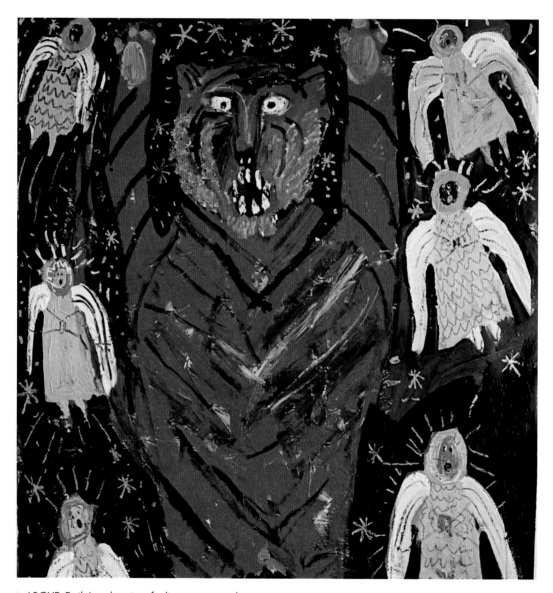

ABOVE: Emily's task: a tiger feeling empowered

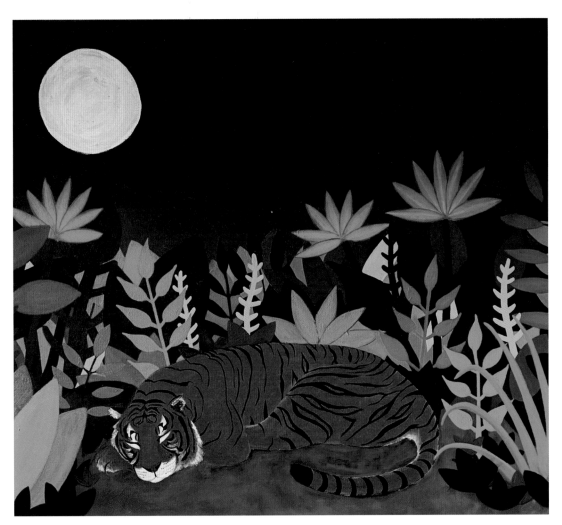

ABOVE: Sarah's task: a tiger feeling safe and protected

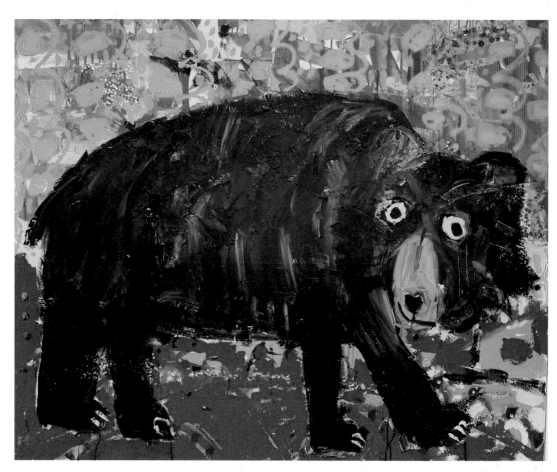

ABOVE: *Curious Bear, Emily Powell,* 2021, 120 x 180 cm, mixed media on canvas
OPPOSITE: *Five Minutes Peace, Sarah Moore,* 2022, 20 x 30 cm, acrylic on canvas

More, more, more!

a. Choose a different animal that really speaks to you and repeat the process – which animal you choose will be another element in helping you express what it means to be you.

b. Why not try reversing the situation and painting how you want to feel? If you're feeling hyper or anxious, paint a calm tiger snoozing in a hammock. If you're feeling scared, paint yourself as a roaring tiger. See how empowering this process can be and what effect it has on your mood.

'Vulnerability is the birthplace
of love, belonging, joy, courage,
empathy, and creativity.'

- Brené Brown

RIGHT: The Neighbourhood Gang,
Emily Powell, 2021, 120 x 180 cm,
acrylic on canvas

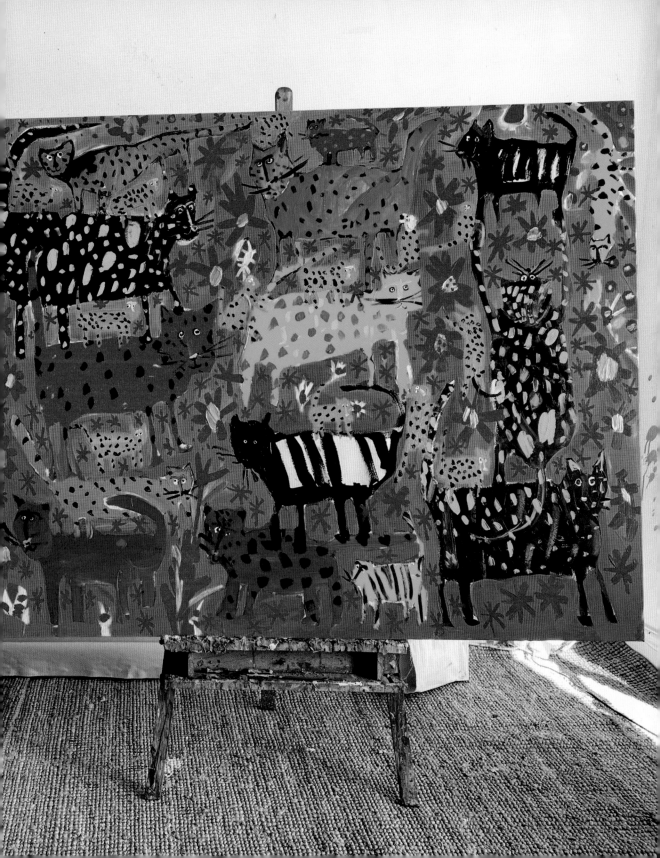

PART 3

Stretch yourself

7. Go BIG

'I decided that if I could paint that flower in a huge scale, you could not ignore its beauty.'

- Georgia O'Keeffe

Large-scale painting

Painting *BIG* can change your life.

That's not something we're saying lightly. We honestly believe it. The scale of our work can influence us in many ways, from the subject matter we choose to the impact of our paintings. Scale also affects our emotions and can ultimately lead to increased self-confidence and a sense of empowerment.

This chapter will introduce you to large-scale painting and explore how to achieve the joyful liberation of painting like nobody is watching. Our featured artist is the groundbreaking Abstract Expressionist Lee Krasner, and Emily's reaction to her work is filled with the joy of working on a large scale. Finally, your task is to . . . guess what? Paint BIG!

> '*Art is a magic which makes the hours melt away and even days dissolve into seconds*'
>
> *- Leonora Carrington*

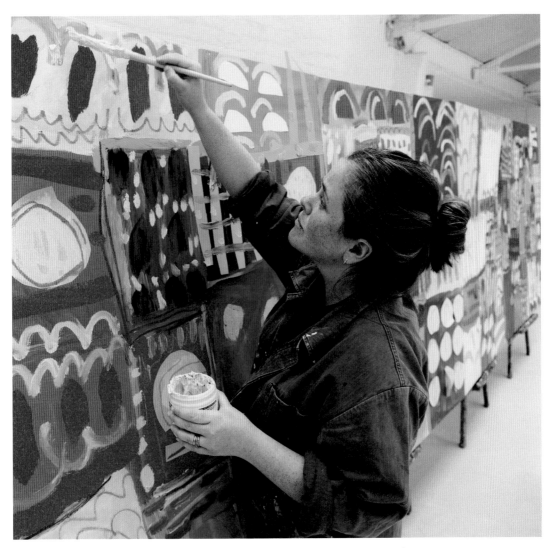

PREVIOUS PAGE: And Then They Lived Wildly, *Emily Powell, 2020, 200 x 300 cm, oil on canvas*
ABOVE: *Emily painting a large-scale work*

Why paint *BIG?*

Painting BIG can be hugely empowering, allowing us to make grand statements about what matters in the world using expansive gestural marks. When we feel intense emotion we need to express it in some way and often in a big way, for example laughing until you cry or screaming in frustration! But we have great news: you can also paint those emotions out!

Painting big is the equivalent of standing up and saying **'I am here, this is me and I deserve to be here'**. By painting this size and owning it, you're claiming your place in the world and we find that this can be incredibly powerful.

The bigger you paint something, the more important you are making it. Through history, the biggest artworks have often referred to the themes thought most significant at the time – religious frescoes, battles or portraits of 'important' people. Over time, however, this narrative became subverted as artists and audiences began to push back against the traditional approach. Nowhere was this more true than in the emergence of Abstract Expressionist art in the United States of America in the mid-twentieth century and we will explore the work of one of these artists, Lee Krasner, on page 146.

Gestural abstraction or *action* painting

This is painting that comes from the heart with instinctive application of paint to canvas. What matters is not *what* gets painted but *how* it gets painted. As the artist, you're required to be honest and express yourself intuitively with the paint. You'll see that a lot of these paintings are huge, to reflect the expansive gestures needed to portray this expression. At the end, the finished object is a record of your gestures and the emotions you felt as you painted.

*ABOVE: Marked Emotions,
Emily Powell, 2021, 200 x200 cm,
mixed media on canvas*

'A painting to me is primarily a verb, not a noun, an event first and only secondarily an image.'

- Elaine de Kooning

Jumping for *joy*

Did you know that how you move can affect your emotions? Why not try it? Throw your arms out wide, look up to the sky and jump in the air. How does it feel? These expansive, expressive body movements are associated with happiness. We've always found that our best painting is the result of accessing our emotions. Painting big strokes from the shoulder mirrors the expansive gestures that produce positive emotions such as joy, so it's no surprise they make us feel happy!

Did you also know that how you feel can affect how you move? Emotions can make us move in particular ways. Imagine you've just finished work for the weekend and you're feeling free, how do you move? Like you're floating on air, light as a feather, wanting to look to the sky and with the whole world laid out in front of you? You can use these feelings to influence your work in the marks you make and the colours you choose. It's amazing how universal this language is.

Emily – What is happiness? For me it involves being in touch with myself, being aware of my needs and concentrating on what I love. In terms of painting this is about following my instincts, especially the joy I find in good colours sitting next to one another. I fully believe you can paint yourself happy. By listening to your emotions, consciously thinking about positive outcomes and being kind to yourself, you can give yourself a huge leg up on the happiness ladder.

Paint your emotions

Why not try this out on a big piece of paper? Tune in to how you are feeling or simply pick an emotion such as excitement – then paint it out. What colours will you use? What marks will you make? What will you use to make those marks? Will the painting be fast or slow? Try this out with different emotions and see how the act of painting them makes you feel. If you want to extend it a bit further, why not show your pieces to others and see if they can guess what emotion you were painting?

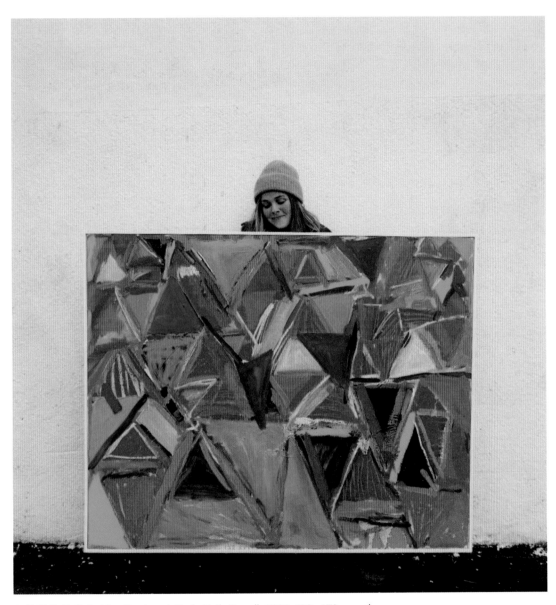

ABOVE: Emily holding Patchwork Quilt, Emily Powell, 2020, 110 x 170 cm, oil on canvas

The *flowzone* **layer**

You know that feeling when you're dancing and you've forgotten everything else other than the rhythm of the music and the joy of moving your body? That's what we want you to feel like when you're painting: fully immersed in the joy of a physical, creative energy. It's not always easy to achieve but once you've been there, you'll just keep wanting to go back!

This sense of deep concentration, where your senses are heightened and the rest of the world fades out, is often referred to as 'flow' or 'in the zone'. We prefer to think of this as the flowzone and the aura it creates as the flowzone layer – think ozone layer but for creativity! This layer develops around us as we become increasingly engaged in our task and protects us from worries and stress. At the same time our positive energy, generated from the activity, is radiated back to us, enhancing our experience. There's no stopping a river in full flow and that's what our creativity feels like at this point. We both absolutely love achieving this immersive, joy-filled state. There are many ways to achieve it but we've found one of the best ways to get there is to paint BIG.

'The place where I had freedom most was when I painted. I was completely and utterly myself.'

- *Alice Neel*

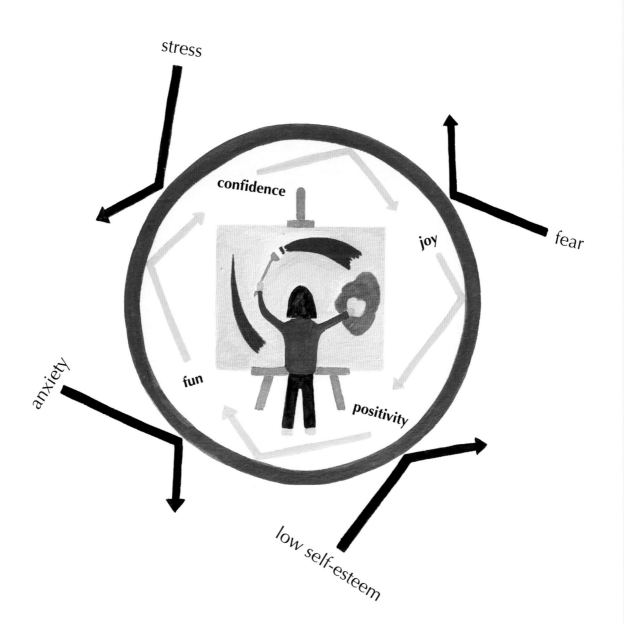

stress

fear

confidence

joy

fun

positivity

anxiety

low self-esteem

Lee Krasner
1908–1984

ABOVE: *Lee Krasner standing in front of her artwork, 1959*

Lee Krasner's huge paintings are absolutely pumped full of emotion. At the heart of the Abstract Expressionist movement in New York in the mid-twentieth century, Lee referred to her work as 'physical painting'. Initially her paintings were completed in a small room and were correspondingly limited in the gestures and size of painting she produced. When Lee finally got access to a huge barn studio, her work expanded to fill the space. In the grip of intense emotions, she would paint long into the night, unable to stop. That intensity vibrates from the canvas in her choice of colours and the marks she made.

Integral to Lee's work was constant exploration and evolution, indeed she once said 'I have never been able to understand the artist whose image never changes'. Lee would work in cycles, experimenting and adapting depending on her circumstances. When a cold winter forced her to work in the living room, she made mosaic table tops, and at a time when she grew frustrated with her paintings and ripped them up she looked at them lying on the floor and saw the next step: collage. This constant desire to learn and develop is a true inspiration.

> *'I think my painting is so autobiographical if anyone can take the trouble to read it.'*
>
> *- Lee Krasner*

▌ *ABOVE: Combat, Lee Krasner, 1965, 179 x 410.4 cm, oil on canvas*

What can we *learn* from Lee?

1. Change is good! Keep on experimenting and exploring, look for happy accidents like the idea of collage coming from paintings torn up in frustration!

2. Channel your emotions into your work. You'll feel better for it and the paintings will speak directly to your audience, with no need for explanation.

3. Colour is a powerful way to express yourself and doesn't need to be complex. Paring back your colour palette often has a more powerful impact than using a whole rainbow.

Emily's reaction to Lee Krasner

At one of the hardest points of Lee's life, she began painting huge canvases right through the night. Looking at her work I can feel how her strength grew through this process. She used her feelings to rip into paper and paint with massive brushes, stretching to her full extent. Once, when she broke her painting arm, she was so passionate about her work that she taught herself to paint using her other arm and worked directly with her fingers on the canvas. As her paintings grew and developed in power and confidence, so did Lee. Her paintings signalled to the world that she was serious and proud of her work. She used her emotions and flew them like a flag of pride that said, yes I'm human, yes I feel, and no I'm not going to apologise for that, I'm going to paint them HUGE!

Lee Krasner makes me feel strongly part of something special, the thing called life. Her work is so authentic it sends chills down my spine. Seeing her abstracts in real life made me run for the big canvas and brushes and have a go myself. It's one of my favourite paintings. It's a picture of just exactly where I was at the time. Nothing figurative, just big emotions – BAM! Love you Lee.

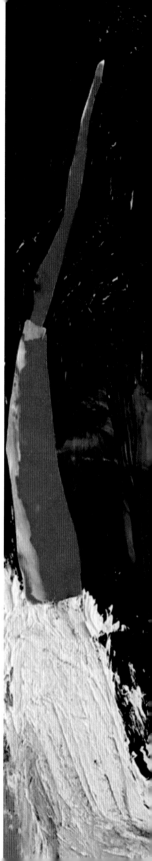

OPPOSITE: Honest Emotion,
Emily Powell, 2021,
100 x 120 cm, mixed media
on canvas

'I like a canvas to breathe and be alive. Be alive is the point.'

- Lee Krasner

Go BIG

This task is an opportunity to try out what we've explored in this chapter. What we want you to do is have fun, let go and find joy in the process rather than worry about the outcome. If at all possible, work in a place where it doesn't matter if you make a mess – and wear clothes that you don't mind getting paint on. This is all about freedom of expression and letting go, and we don't want anything to get in the way!

1. Find a big surface to work on – try a skip or a local recycling website for a piece of wood or board. Take the cardboard from a really big box or treat yourself to a big canvas.

2. Get out your favourite paint colours and find your biggest brushes, it's time to step right out of your comfort zone.

3. Now it's time to enjoy the surface – there are no rules, of course, but here are a few ideas to get you started:

> **Top tip** – Try not to work too much with wet paint on top of wet paint or your colours can become quite muddy. Working with fast-drying paint like acrylic makes this easier if you're impatient like we are!

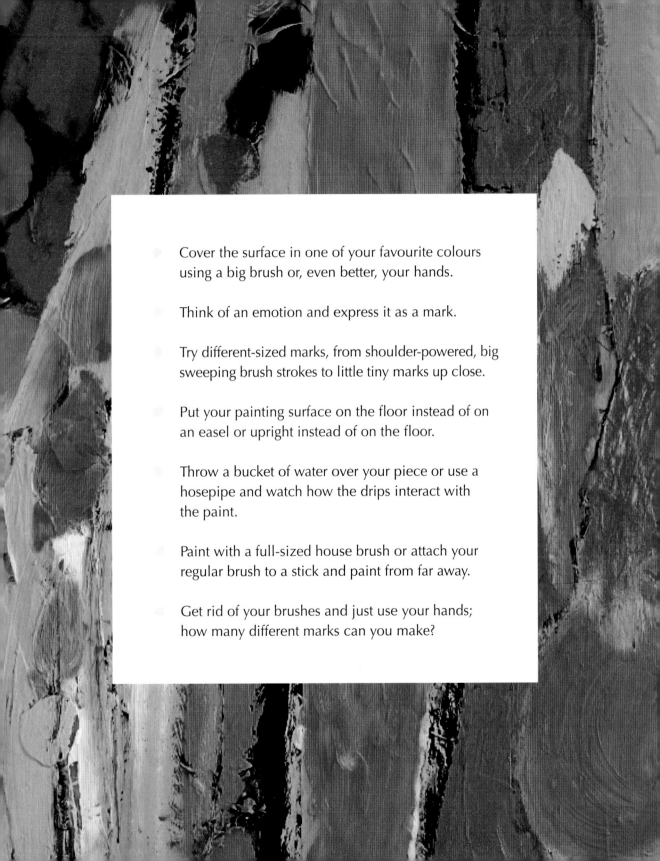

Cover the surface in one of your favourite colours using a big brush or, even better, your hands.

Think of an emotion and express it as a mark.

Try different-sized marks, from shoulder-powered, big sweeping brush strokes to little tiny marks up close.

Put your painting surface on the floor instead of on an easel or upright instead of on the floor.

Throw a bucket of water over your piece or use a hosepipe and watch how the drips interact with the paint.

Paint with a full-sized house brush or attach your regular brush to a stick and paint from far away.

Get rid of your brushes and just use your hands; how many different marks can you make?

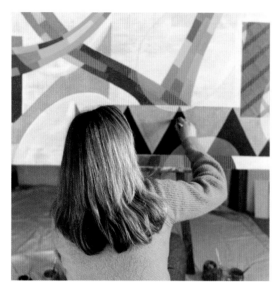

PREVIOUS PAGE: Detail from Pink and Red, *Emily Powell, 2021, 100 x 180 cm, mixed media on canvas*
ABOVE: Clockwise from top right: Emily holding The Midnight Garden, *Emily Powell, 2021, 100 x 200 cm, oil on canvas;* Parrot, *Emily Powell, 2021, 200 x 220 cm, oil on canvas;* Sarah painting a big work in progress
OPPOSITE: Never Forget How Wonderful You Are, *Emily Powell, 2019, 100 x 180 cm, mixed media on canvas*

More, more, more!

Hopefully you're feeling great about the abstract piece you've produced and are ready for another challenge. While you're feeling full to the brim with the joy of painting, dive in and paint a BIG PROMISE to yourself like, 'I will paint more' or an UPBEAT PHRASE like, 'Never forget how wonderful you are'. Now get your painting on the wall and we dare you not to smile every time you see it!

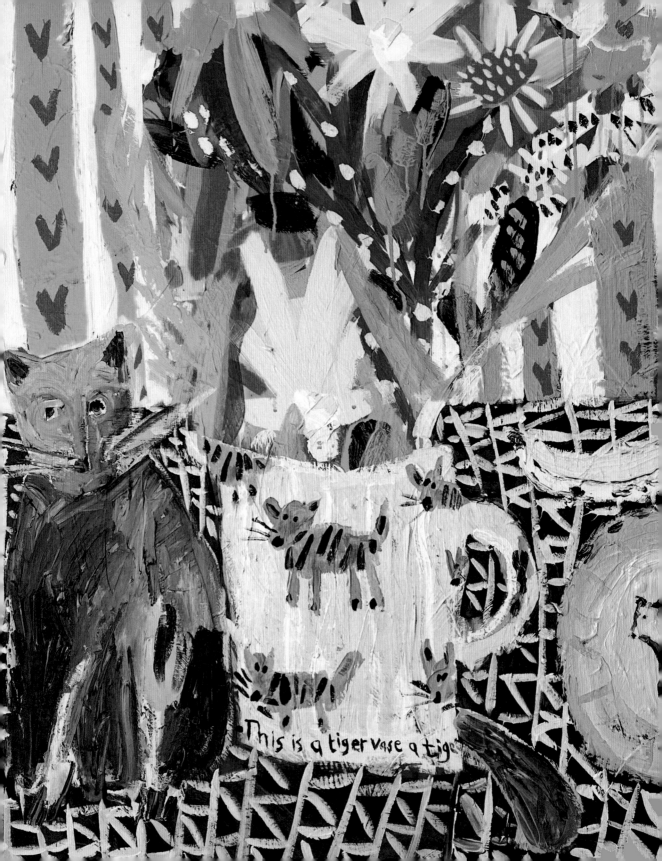

This is a tiger vase a tige

8. Go inside

*'I paint pictures which do not exist
and which I would like to see.'*

- Leonor Fini

Home comforts

You know that warm, contented feeling you get from the *cosy* hug of a duvet on a chilly day or the perfect cup of your favourite tea? For us, painting inside is all about *capturing* these feelings.

Taking everyday moments and celebrating them for what they are. Truly special. In this chapter, we guide you through the things you might want to paint and how you can employ your imagination when painting them. We also explore how crucial it is to have a space of your own for painting and bring you some top tips on elements to include to help make it successful. Our fabulous artist is Elizabeth Blackadder, a queen of still life composition. Emily's reaction to her will have your imagination running wild ready for our task, which will help you see your favourite objects in a whole new light!

'I feel so intensely the delights of shutting oneself up in a little world of one's own, with pictures and music and everything beautiful.'

- Virginia Woolf

PREVIOUS PAGE: The Banana and The Cat, *Emily Powell, 2020, 100 x 100 cm, mixed media on canvas*
ABOVE: Hope, *Emily Powell, 2021, 100 x 100 cm, mixed media on canvas*

Q. What's the subject?
A. *Anything!*

We both love putting on an audiobook and getting well and truly stuck into a painting. Sitting in our creative space, the world fades away and we can concentrate on celebrating the everyday objects that surround us in our homes. We would love you to have that same experience and hope that this chapter can set you up ready for it!

Painting what **you** want to paint is the key here. Remember what we discussed in chapter one about the power of positive choice? Positive choice sets you up for success. Here, it's about choosing the subjects that speak to you rather than what you think you should be painting. By choosing to paint familiar objects with emotional resonance, your paintings will be imbued with those feelings, making them enjoyable to paint and full of energy.

By celebrating the mundane and the everyday, you are stepping away from the traditional idea of art being only for the elite, whoever they might be! Instead, by using familiar objects, your paintings are relatable and make the viewer feel at ease. They also tell the story of your life.

'Art is the only place you can do what you like. That's freedom.'

- Paula Rego

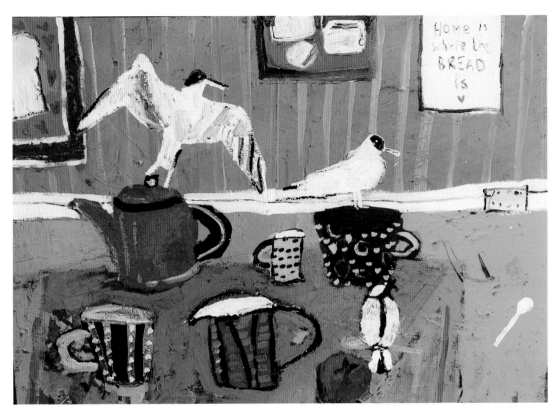

ABOVE: Home Is Where The Bread Is, *Emily Powell, 2019, 70 x 100 cm, mixed media on canvas*
BELOW: *Sketchbook detail, Gidleigh Park, Emily Powell, 2021, mixed media on paper*

There are no rules here. Still life is traditionally formed of non-living things but we love adding plants or animals and you'll see this too in the work of our artist for this chapter, Elizabeth Blackadder (page 166). Ultimately, we want you to **paint what is important to you**, whether it is a mug of tea, your cat or a family heirloom. By painting these objects repeatedly and in different ways you will slowly get to know them better, until they feel so familiar you could paint them with your eyes closed. Watch out, though – those objects will develop a life of their own and you'll soon find them sneaking into other paintings!

Painting *your* **imagination**

Imagination lies at the root of creativity and is super important to your painting practice. We are both great fans of painting in a way that uses our imagination. This can range from reshuffling compositions in our heads to juxtaposing items that surprise us, to adding wings to donkeys and bow ties to cats! In the tradition of Frida Kahlo, we want to expand painting beyond what we see in front of us and bring our own unique and wonderful version of reality to our work.

Remember your inner magpie from chapter five? Well, your magpie and its box of shiny things is going to be really useful here. By storing up all these pieces of inspiration, your brain can make the leap and link them together in unusual ways to produce novel ideas. The more experiences you store up, the more platforms your imagination will have to jump off from when it goes on its next exploration.

Beyond our conscious imaginations lie our dreams, another wonderful source of imagery and ideas. Did you know that the visual areas of your brain light up when you're dreaming? Freed from the rational policing of your conscious brain, they can put together all sorts of strange images. Even if you think you don't dream much, try keeping a notebook by your bed and capturing your dreams in written or pictorial forms just as you wake up.

> RIGHT: Emily Powell works from top to bottom:
> Tigers, Honey and Toast, 2021, 70 x 70 cm, mixed
> media on canvas; Zebra in the Garden, 2019,
> 42 x 60 cm, gouache on paper; New House,
> 2019, 35 x 80 cm, mixed media on canvas

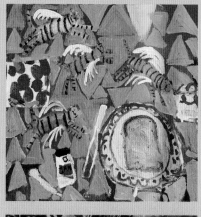

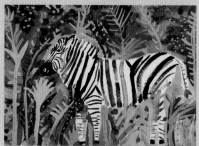

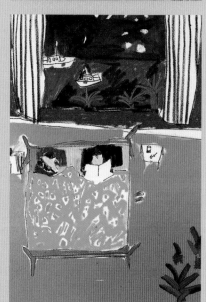

Beyond *reality*

One group of artists who used their dreams as inspiration were the surrealists. Surrealism essentially translates to 'beyond reality' and the aim was to free the mind from the rational. One of the techniques used to achieve this was 'automatic painting', in which you paint whatever comes into your head without thinking about the consequences. A fun way to try out the surrealist ideas is by playing the group game 'heads, bodies, legs', where a piece of paper is folded into three and each person adds a component without seeing what the others have drawn. The odd juxtapositions of images that result from this are often hilarious!

Sarah – Did you know that if you're a worrier you have an excellent imagination? I don't know about you but my imagination is really good at coming up with the worst possible outcomes and most of the time these worries are a massive waste of my creative energy! This simple realisation blew my mind. It hasn't stopped me worrying completely but it has helped me to reframe my understanding of what is happening when I worry and to recognise it as a sign of a wonderfully active imagination!

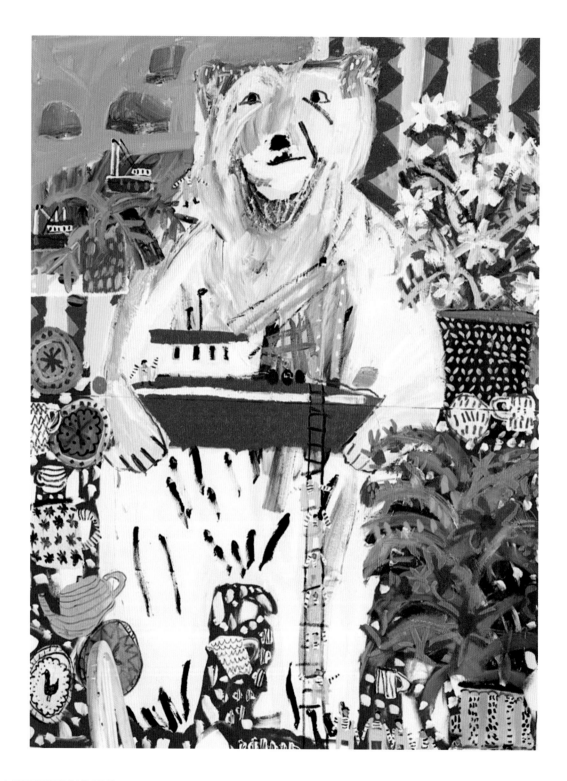

Emily – I think in pictures and sometimes, when I'm painting, a visual will float in that needs to be added. Fortunately, my mind has a lot of objects and stories floating in it. This huge Polar Bear painting is a great example of my process. Here, I started off with a giant polar bear on a blue background. I liked him but I felt he needed a home and some real warmth adding – hello striped wallpaper! I thought next about how he was so mighty that he'd be good at protecting the fishermen I see out of my window, so in they went! I'd also been looking at a lot of homeware magazines and thought it would be unusual if he had an on-trend china collection… This is how I build up these paintings, feeling my way through, using the visual elements that present themselves to me to create strong narratives filled with imagination.

ABOVE: *Emily painting a work in progress*
LEFT: *Protecting the Fishermen, Emily Powell, 2021, 120 x 220 cm, oil on canvas*

A *space* **of one's own**

Do you really use that shed/under-stair nook/ attic for useful things, or is it just filled with clutter? How could you repurpose your environment to make best use of the available space and prioritise your need to create? It might be a small desk in a corner of a room, a refurbished shed or a dedicated studio. We would absolutely urge you to try to find a physical space to work in if you can, but we recognise this won't be possible for everybody. In this case your space might not even be physical but instead related to time, such as before the rest of the house get up or after they have gone to bed.

The base layer of the cake of self-care (page 45) is about the environment in which you work, the foundation on which the rest of your creativity sits. Now is your opportunity to put some real thought into making the perfect space for you. No two people will have the same requirements of their creative space but here are a few things we think are really handy when setting up a space for painting:

- natural or good artificial light
- interesting objects
- storage space
- art books and magazines
- a place to sit and reflect

Sarah – Ever since I was small I've loved having a place I can retreat to and be creative. Now I'm lucky enough to have my own studio in the attic of our house and it's an absolute joy. It's a great space for some introverted unwinding and I find that I'm much more likely to be creative when I can leave my work out to jump straight back into when I'm ready.

Emily – Like most millennials, I've moved from rented accommodation to rented accommodation! So I've had to adapt my art area to wherever I am. The truth is that anywhere works well – it just has to be absolutely dedicated to art. When I started, I had three red boxes of equipment next to an easel in an open-plan living room and now I've managed to get a studio above an old bakery in town. Neither one is better; it's all about making the most of the space you have available.

OPPOSITE: Clockwise from top: Emily's studio. On the easel They're Swans Not Geese, Emily Powell, 2021, 200 x 200 cm, oil on canvas; Sarah drawing in her studio

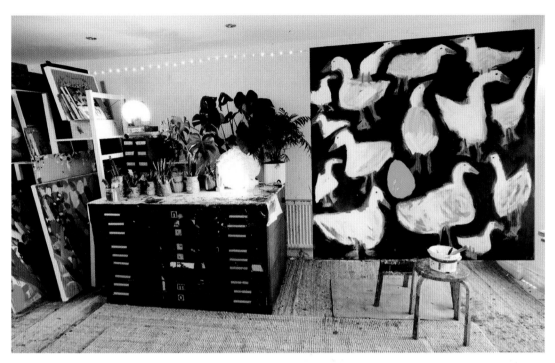

Elizabeth Blackadder
1931–2021

ABOVE: Elizabeth Blackadder following her Royal appointment to the ancient position of Her Majesty's Painter and Limner in Scotland, 2011
OPPOSITE: Flowers on an Indian Cloth, Elizabeth Blackadder, 1965, 102 x 77 cm, oil crayon on paper

Elizabeth Blackadder was equally at home painting bold still life compositions in oil or delicate watercolour botanical illustrations. She switched between them easily, using the medium she felt worked best for the current painting. To the viewer, what shines through in her work is the excitement and enjoyment she took from her surroundings. This stimulation seems to provide the source for her creative energy, driving her to paint her environment and share it with the world. And the world noticed, no less so than when she was the first woman ever elected to both the Royal Academy and the Royal Scottish Academy.

Elizabeth was a great collector of objects that she saw and wanted to paint. Her passion for collecting interesting items began young, when her father would bring back things from his travels for her. She also developed an early passion for flowers. As she grew older, Elizabeth began to create her own collection of things that fascinated her. This collection, in addition to fresh flowers and her cats, have provided the subjects for her still lifes. Talking about how she composed her paintings Elizabeth remarked, 'I have an idea in my head but the idea may change in the course of the painting'. This versatility of thought combined with connection to her subjects has produced a remarkably diverse and interesting body of work for us all to enjoy.

'Once you start there's an image on the paper that really dictates in a way what's going to happen next.'

- Elizabeth Blackadder

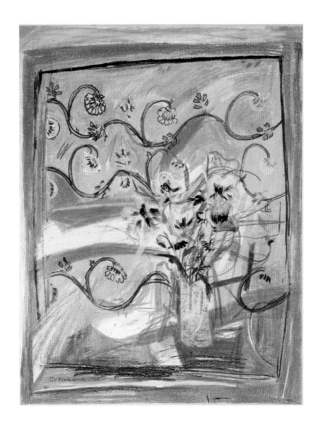

What can we *learn* from Elizabeth?

1. You can let the composition develop as you paint and it doesn't need to correspond to what you see in front of you! Start with one object then move onto the next . . . try this out in the task on page 170.

2. Versatility is a great thing! You don't have to stick to one type of paint or one subject – experiment and explore what works best for you and you'll find your work develops along the way.

3. There's nothing wrong with painting what you want to paint, in fact it is a huge strength to be able to recognise what interests you because your passion for the subject will shine through in your painting.

Emily's reaction to Elizabeth Blackadder

The calmness of Elizabeth Blackadder's work really draws me in. There's a quiet peacefulness to the colours and the composition that you can't help but absorb. Ever present in her work is her strong and unusual sense of composition. Objects are placed together in ways that shouldn't make sense but when she paints them, they seem to feel so at ease in each other's company. Each colour she uses reflects her environment. Elizabeth even brings a muted calm tone to her yellows while still making the work feel positive and uplifting. This is impossibly hard to do but still she manages it; I have so much to learn from her work!

Flying donkey is an indoor reaction painting to Elizabeth Blackadder's work. I wanted to get lots of household objects in and really make the most of the details that you can concentrate on when indoors. I found when painting it that I went almost completely into a trance-like state. The world slowed down as I listened to an audiobook and painted objects from my kitchen. The flying donkey, the cat with the bow tie and the lion are all based on animal figures I have around the house but they came alive in this painting. I think they may have come alive because there was time and space for them to do so . . .

*'I think painters do collect
. . . a lot.'*

- Elizabeth Blackadder

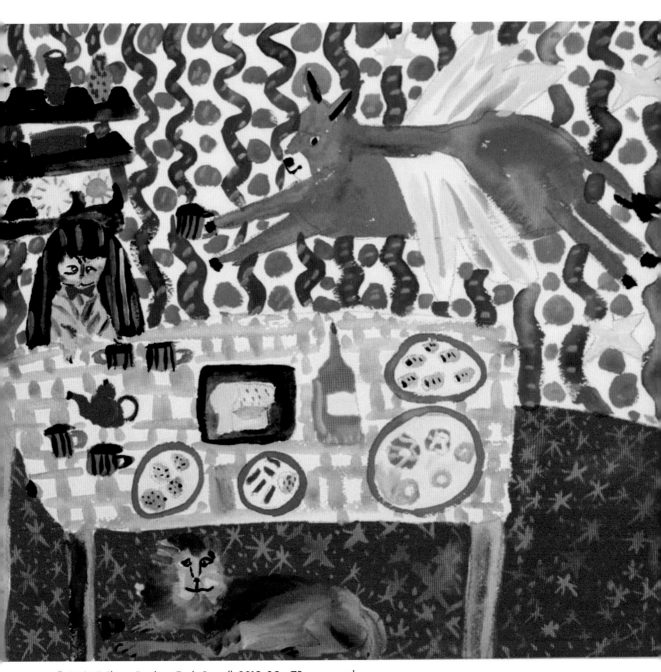

▍ABOVE: Flying Donkey, *Emily Powell*, 2019, 35 x 75 cm, gouache on paper

Getting to know your objects

This task is all about celebrating the mundane and the everyday, getting to know the objects around you and beginning to experiment with composition. This is a great one to revisit regularly and you can pick bits to use as a fun warm-up exercise if you're not sure what to paint.

1. Take one everyday object you love, such as a teapot, a plant or even a cat!

2. Get a stack of paper, along with a pencil/pen/paintbrush or even a few different materials in similar colours.

3. Now it's time to draw and paint your object in many different ways – here are some examples that you might want to try to get you going:

 - Paint it in two minutes – set a timer!

 - Paint it with your eyes closed – no peeking!

 - Draw it as one continuous line – no lifting your pen!

 - Paint it just with shading – no lines allowed!

 - Draw it upside down – try doing that one without sticking out your tongue in concentration!

4. Paint a big piece of paper in a contrasting colour.

5. Now cut out all your paintings and arrange them on the paper to make a still life celebrating your object.

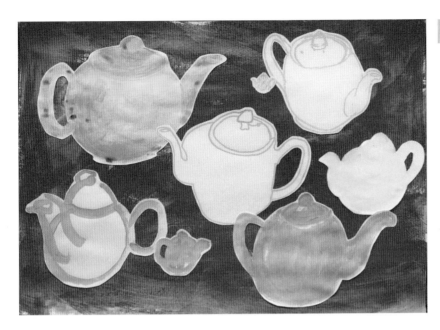

More, more, more!

Repeat with other objects and build a whole set of images that you can mix up and rearrange to make still life compositions. Once you've stuck them down, paint in and around the objects. Fill in a background, add in details, make it a story – do whatever you feel is right. Share your reality!

9. Go outside

*'It is in the everyday things around us that
the beauty of life lies.'*

- *Laura Ingalls Wilder*

Elements of innovation

Painting outside is the one-stop-shop to endorphin overload and *carefree* work.

The limited materials, the world in technicolour, the time constraint and the energy of the weather all add up to a fabulous, joy-filled learning experience. In this chapter, we introduce you to the importance of a connection with nature for your creativity, troubleshoot the fears that sometimes accompany outside painting and furnish you with a kit list to get you started outdoors. Joan Eardley provides our inspiration, equally at home painting in the tenements of Glasgow or on the wild Scottish coast. Emily channels Joan's tenacity in pursuing elemental painting and then it's over to you to capture your own interpretation of the world around you with our elemental scribbling task.

'My painting is very much a reflection of my immense love for the world, the happiness to just be, for nature, and the forces that shape a landscape.'
— Etel Adnan

PREVIOUS PAGE: Above the Fishing Port, Emily Powell, 2021, 180 x 200 cm, mixed media on canvas
RIGHT: Emily and Sarah painting at Sharkham Point, Devon, 2021

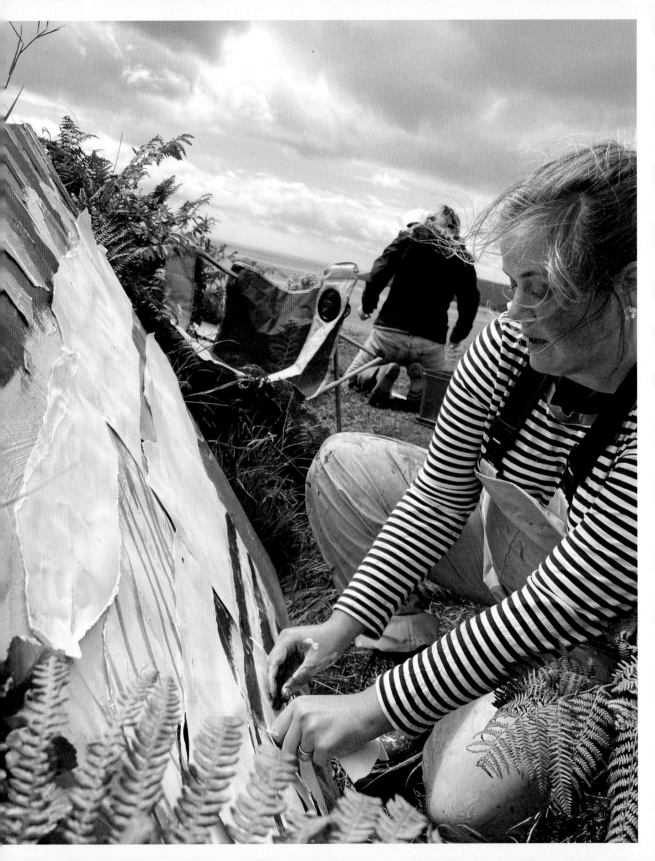

Natural *connection*

Painting outside (also known as 'en plein air') gives us such a rush of good happy feelings and massively boosts our creativity. It is a time for experimenting and surprising yourself, innovating with reduced time and materials and added complications, such as the weather! We find being out in the elements is truly invigorating and the energy it generates can sustain us for days back in the studio.

Did you know that the more connected you are to nature, the happier you are? We hear a lot about this in the news and all sorts of scientific studies have shown it to be true, but how does time in nature improve your mental health and how does this help your creativity?

You know that feeling of being constantly bombarded by texts/emails/calls/life?! Well, that's known as 'attention overload'. Your ability to concentrate on anything is destroyed because your attention is being drawn by everything! Being out in nature gives your brain a chance to rest and recover, allowing your focus to be turned to one thing at a time. This improves your memory, your ability to solve problems and allows you to think creatively.

In addition to helping us escape our busy everyday lives, there's something special about connecting with nature. When you are outside, your sense of wonder at the world around you can make you feel like time has slowed down and, as a result, everything suddenly seems possible. Add to this that experiencing the beauty of nature enhances your positive emotions and that time connected with nature improves your sleep. Boom – that's a pretty good recipe for you to boost your creativity!

WEATHER

Sarah – I absolutely love the wind. The sound as it whistles past and the raw energy on my face. The way the natural world can't help but react to it – leaves blowing, trees bending, waves crashing. It's why I can't live in a big city and why I love the coast. Wind whips away the bad stuff and makes me feel reborn. It makes me feel alive.

Emily – I like all the sounds and textures of weather, the crispy grass on a cold October morning feels so magical. And I love the sun, when it lights up everything in your path and makes the sea realise its full green colour potential – swoooon! But I think what fills me with most joy is how the weather changes; from minute to minute, day to day, season to season. I can't help but be excited by things that change!

Over to you – What kind of weather makes you feel alive? Where do you go to experience it? Try our task on page 188 to start translating those sensations into elemental marks.

So, how do you achieve this connection to nature? It's pretty simple: the more time you spend in nature, the more connected to it you feel. While spectacular scenery is a bonus, the good news is that you don't need to be in a so-called 'beauty spot' to get the benefits of going outside to paint. The key thing is that you get out regularly. Even twenty minutes a day can help increase your energy! We reckon that's why we feel so refreshed after painting outdoors. Not only this but our paintings evolve so much more quickly than they do in the studio. This really is a win–win–win situation for painting!

'I felt my lungs inflate with the onrush of scenery – air, mountains, trees, people. I thought, "This is what it is to be happy."'

- Sylvia Plath

BELOW: Sharkham Point, Emily Powell, 2021, 70 x 70 cm, acrylic on canvas

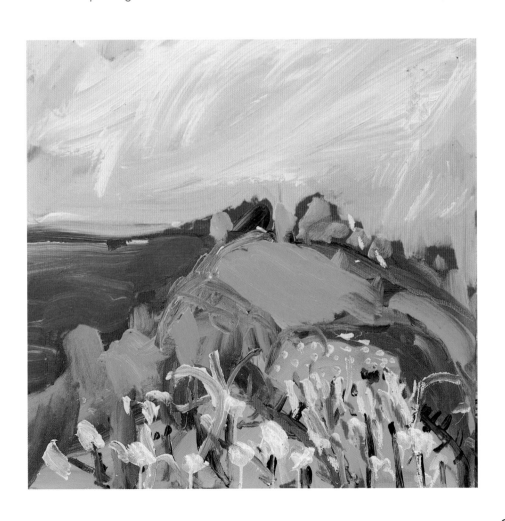

Outdoor painting *kit list*

Enough theory. Time to get your painting hat on (bonus for creative hats . . .) and get out there! Here is our take on the best kit to take on outdoor painting expeditions.

The basics
Prepare for success by kitting yourself out for your environment.

- *Backpack* – so you can keep your hands free when walking on cliff edges, etc and also great when carrying equipment.
- *Snacks* – painting outside is the happy sort of exhausting, so bring good biscuits, nuts, fruit and tea or coffee. Maybe a cold drink too on a hot day.
- *Appropriate clothing* – dress for the weather, whether that's wearing sun cream and a hat or waterproofs and wellies (essential in Britain, where we live!)
- *Good footwear* – vital so you can leap over rocks or paddle to get to good places to paint.

Paint and other materials
A mix of dry and wet media is the best place to start. By rotating your colour choices each time you go out you'll learn a lot and vary your outcomes.

- *Two tubes of gouache or acrylic in a light and a dark colour* – rotate your colour choices.
- *Oil pastels* – really intense colour for quick mark making on the go.
- *Coloured pencils* – useful for detail and particularly good over gouache.
- *One bottle of ink* – to spill over your work, making happy accidental marks.

Things to paint on
Always have more than one surface to work with.

- **Sketchbooks** – we always take at least two out with us so one can dry whilst we paint in the other and then they can be swapped. This way there's no need to stop.
- **Paper** – while this can be a liability on a windy day it's also a liberating way to work as you are freed from the constraints of your sketchbook. Lining paper can be a good choice as you can rip sections off and it's easily attached to the outside of your backpack. You can also rip up sections and use them for collage on your paintings!
- **Canvas** – if there's a handy car park near your painting spot, take a big canvas, but make sure you bring more than one as when you're mid flow you don't want to run out of surfaces to catch your ideas.

Things to paint with
These mark-making tools can be anything! Think outside the box and make the most of the environment around you.

- **Twigs** – collect some sticks from the area you're painting in and try different shapes and sizes to see how your marks vary. These work particularly well with ink or watered-down paint.
- **Hands** – perfect on the go as you already have them with you!
- **Kitchen paper or loo roll** – perfect for big swiping marks and blotting.
- **Brushes** – a big one and a small one.

Extras

- **Baking paper** – this is really useful to put on wet surfaces when carrying artworks home and in between sketchbook pages.
- **Bottle of water** – add it to paint, but if you are by the sea, sea water works well too.
- **Easel** – if you have a small one you can carry with you or if you're painting near a car park take advantage of the opportunity. It changes your perspective compared to painting on the floor!

Traditional *limited* colour palettes

We are absolutely not traditional about our colour palettes! We just take out whatever comes to hand or whatever we think might go with the weather or our moods. However, it can also be fun to play with these traditional colour combinations and see how many colours you can make!

The traditional limited palette includes a warm and cold version of each primary colour plus black and white. Why not have a play?

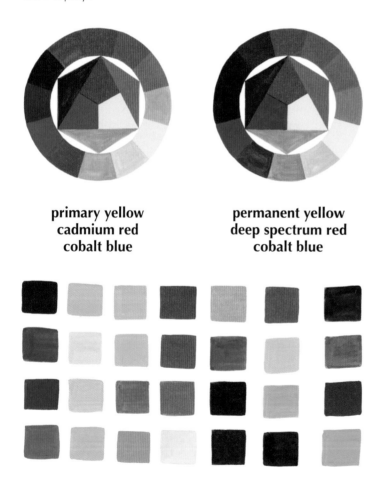

**primary yellow
cadmium red
cobalt blue**

**permanent yellow
deep spectrum red
cobalt blue**

ABOVE: Sarah's paint mixing
BELOW: Sarah paint tests

ABOVE: Sarah's paint palette
BELOW: Emily's paint palette

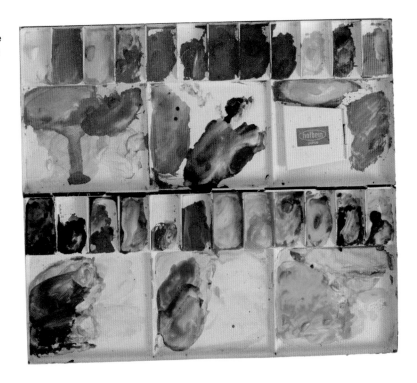

ABOVE: Sarah and Emily painting outdoors on New Year's Day
OPPOSITE: Detail from All the Greens, Emily Powell, 2021,
100 x 100 cm, oil on canvas

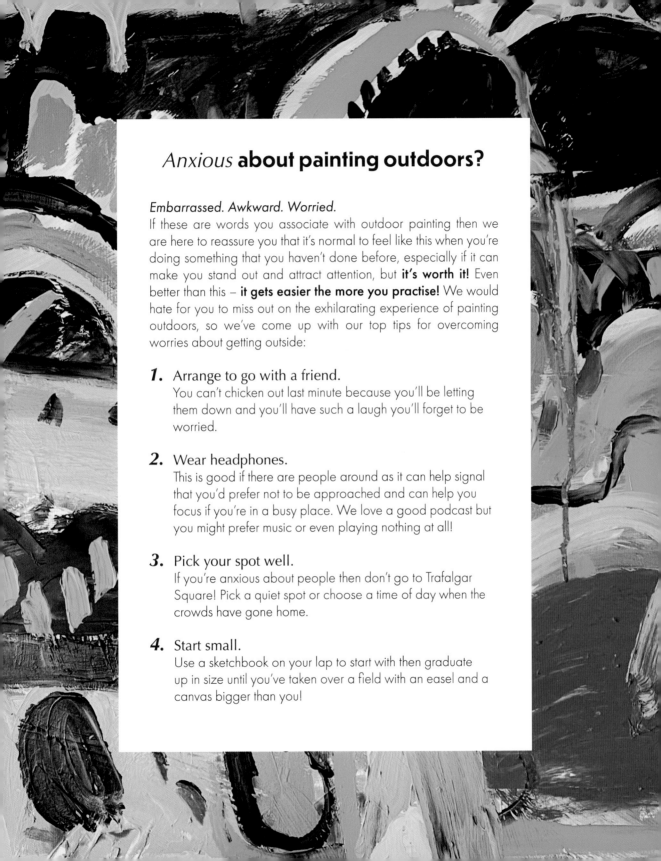

Anxious **about painting outdoors?**

Embarrassed. Awkward. Worried.
If these are words you associate with outdoor painting then we are here to reassure you that it's normal to feel like this when you're doing something that you haven't done before, especially if it can make you stand out and attract attention, but **it's worth it!** Even better than this – **it gets easier the more you practise!** We would hate for you to miss out on the exhilarating experience of painting outdoors, so we've come up with our top tips for overcoming worries about getting outside:

1. Arrange to go with a friend.
 You can't chicken out last minute because you'll be letting them down and you'll have such a laugh you'll forget to be worried.

2. Wear headphones.
 This is good if there are people around as it can help signal that you'd prefer not to be approached and can help you focus if you're in a busy place. We love a good podcast but you might prefer music or even playing nothing at all!

3. Pick your spot well.
 If you're anxious about people then don't go to Trafalgar Square! Pick a quiet spot or choose a time of day when the crowds have gone home.

4. Start small.
 Use a sketchbook on your lap to start with then graduate up in size until you've taken over a field with an easel and a canvas bigger than you!

Joan Eardley
1921–1963

ABOVE: Joan Eardley painting outside, 1961

Joan Eardley fell in love with a place. That place was Catterline, on the wild East coast of Scotland. When she heard tell of a storm approaching, she would rush towards it in an attempt to capture its power. With a board strapped to the back of her Lambretta scooter, she would make her way down to the shore and set up her easel, weighted down to stop it flying away. As she painted her way through snow and gales, her style developed into a form of expressionism that teetered on the edge of abstraction. *The Wave*, painted in 1961, is an energetic example of her elemental style.

Joan did not just live and paint on the Scottish coast. Earlier in her career she rented a studio among the tenement blocks of her native Glasgow and got to know the local families. 'I like the friendliness of the backstreets,' she said. 'Life is at its most uninhibited here.' As a result, she was able to spend time outside drawing the children and documenting the life of the area. As her later paintings capture the wild coast and emptiness of rural Scotland, these paintings record an honest vision of an area of the city that has since been demolished.

'You can't stop observing, things are happening all the time.'

- Joan Eardley

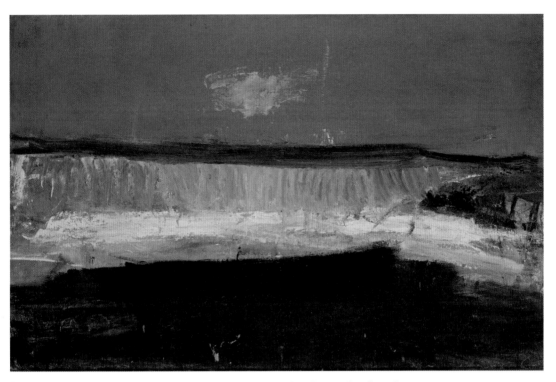

ABOVE: The Wave, Joan Eardley, 1961, 121.90 x 188 cm, oil and grit on hardboard

What can we *learn* from Joan?

1. It doesn't matter where you are, whether in the city, country or coast, you can get outside and create art.

2. Your best work will be done in a place where you feel something, whether that is the friendliness of the back streets of Glasgow or the wildness of a Scottish storm.

3. Getting to know a single place can produce never-ending inspiration, as the more you get to know it, the more you will find to paint.

Emily's reaction to Joan Eardley

I have every book of Joan's paintings ever published. I can't get enough of her work. From Joan's art it's so clear to see she loved elemental painting. Her passion to capture the wild Scottish weather is inspiring and, because she painted in huge storms, her work comes across as very liberated. This sense of freedom, along with her understanding of colour, is the perfect combination for creating utterly passionate, forceful work that takes my breath away. I've always felt sad she died so young but her work is still so alive that I can practically feel the wind on my face.

My reaction to learning about Joan for the first time was to go out and buy full waterproofs, wellies, fisherman's overalls, the lot! Then I took myself out day after day to paint the sea. The easel soaked up so much water it has never been the same and the wind blew everything everywhere but I was so fulfilled and I adore the work I produced in the madness of deep winter weather.

> *'I don't really know what I'm painting, I'm just trying to paint.'*
>
> *- Joan Eardley*

OPPOSITE: Clockwise from top: Bright Night, Emily Powell, 2020, 100 x 150 cm, mixed media on canvas; Resting From the Storm, Emily Powell, 2019, 100 x 100 cm, oil on canvas; Emily painting in the rain, Brixham, Devon

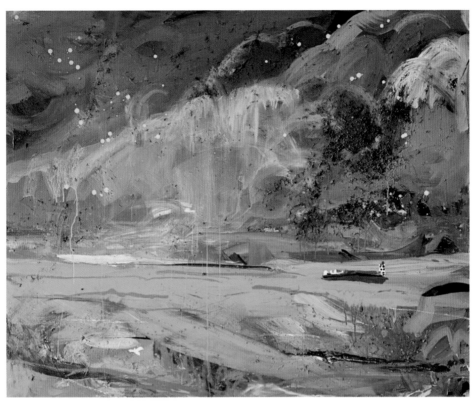

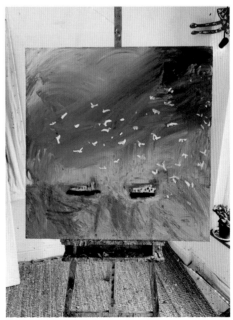

Elemental scribbling

This task is all about capturing what your senses pick up rather than painting a representative image of what you see. We want you to practise translating the energy from being outdoors into marks on the page in a free and abstract way. Time to go outside and play!

1. Grab yourself a sketchbook or some bits of paper and something to lean on – a piece of board can be useful, with your paper attached by tape or clips.

2. Get your painting bag out (this is the perfect opportunity to test your kit from page 178).

3. Head outside to a spot you feel comfortable in and that you'd like to try painting.

4. Use a different page of your sketchbook for each image and try documenting what you feel in that environment – remember there is no right or wrong, this is all about play!

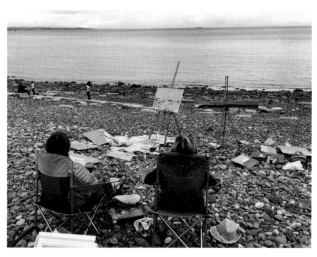

LEFT: Emily and Sarah painting on the beach, Penzance, Cornwall, 2020
RIGHT: Sarah painting with a stick, Brixham, Devon, 2020

5. Here are a few pointers to help you get started:

Page 1. What are the colours of the environment you are in? These don't have to be literal, for example, you might be in a green field but feel there is so much energy coming off it that you see it as bright pink. Build a palette of colours that feel right for the environment.

Page 2. What's the weather doing? Is the sun beating down on you or the wind whipping your face? What colour is the wind? What marks represent the heat?

Page 3. What noises can you hear? Is there a steady hum of traffic in the background or the tweeting of birds? How could you make these into a visual pattern?

Page 4. What can you find around you that you could use to make marks or use as pigments? Twigs instead of brushes, seawater and mud. Practise the marks on your page. Stick in some fallen leaves or strips of seaweed.

Page 5. Bring all your ideas together in a final image that represents how you are experiencing the world around you right now.

6. You might find you want to use multiple pages for each of the ideas above or you might want to split the pages into sections.

7. Finally, remember there's no right or wrong way to do this, you're feeling your way into it, one mark at a time!

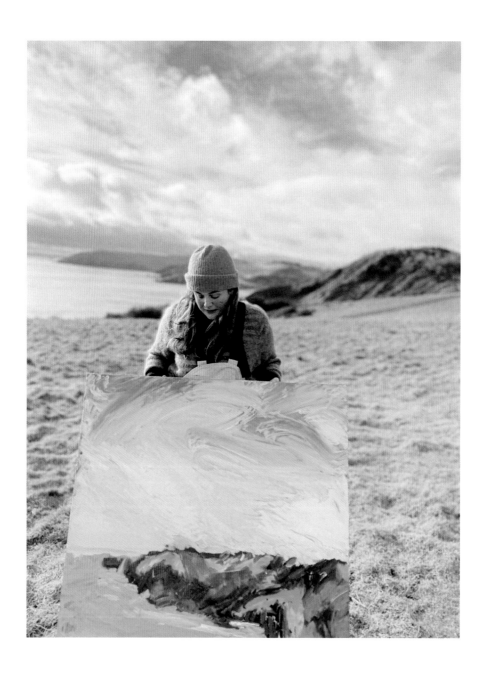

More, more, more!

Once you feel comfortable working outdoors the next step is to work on a bigger surface. Choose somewhere you've already studied that's in your sketchbook. Take an easel and canvases or large sheets of board and use the marks you've practised in your sketchbook to make a cohesive piece representing your experience of the place. Remember, this is about your reactions to what you're seeing and hearing and those will always be unique and special!

OPPOSITE: Emily at Sharkham Point, Devon with Sharkham Point, *Emily Powell, 2021, 100 x 100 cm, oil on canvas*
THIS PAGE: Clockwise from top: Emily painting on the beach, Penzance, Cornwall, 2021; Painting table, Penzance, Cornwall, 2021; Sarah painting on the cliffs, Sharkham Point, 2021
NEXT PAGE: Emily and her sketchbook. Looking Towards Shoalstone Pool, *Emily Powell, 2020, oil crayon*

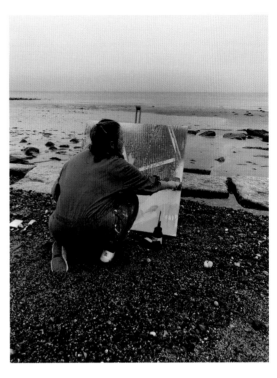

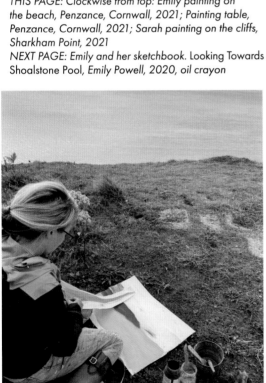

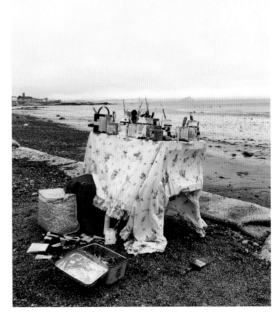

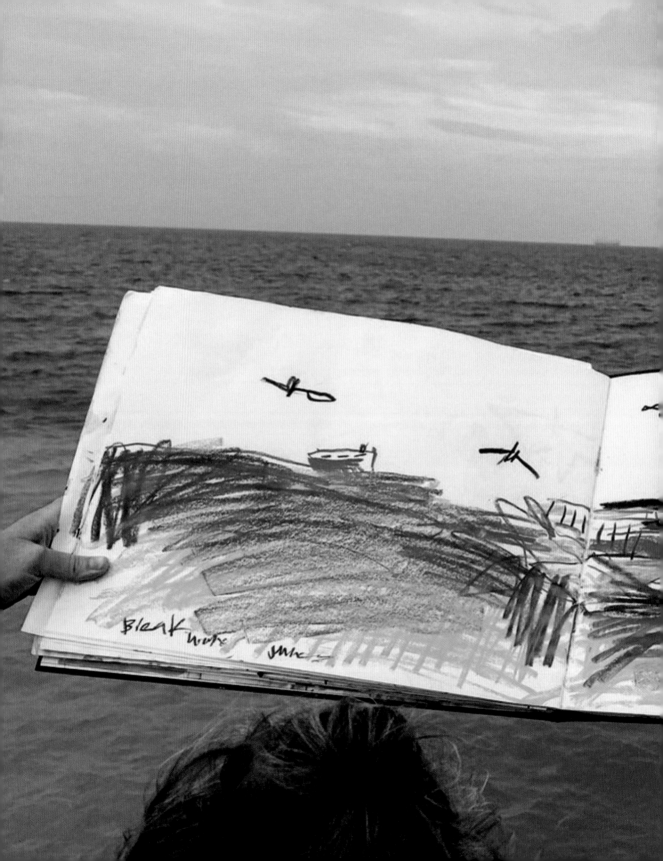

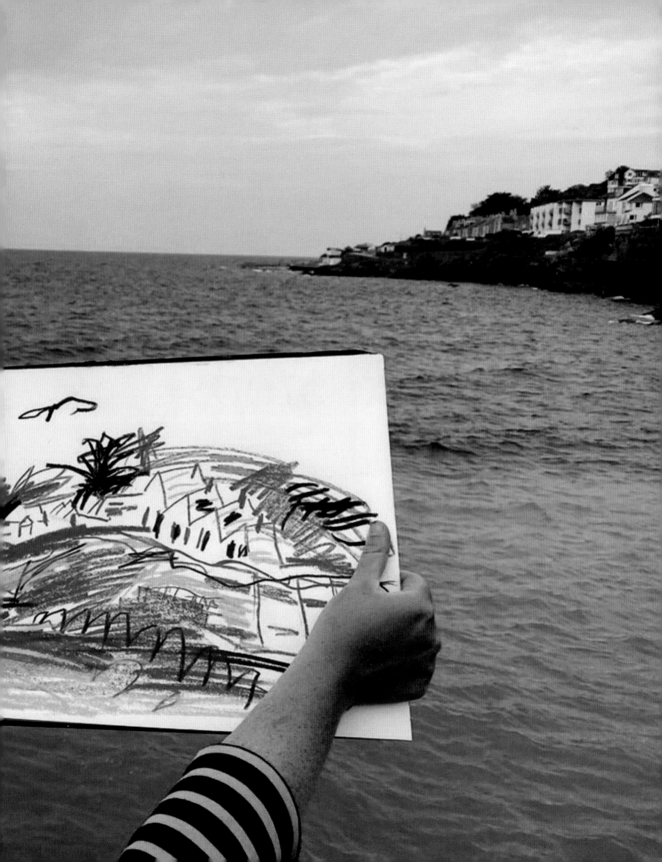

PART 4

Next Steps

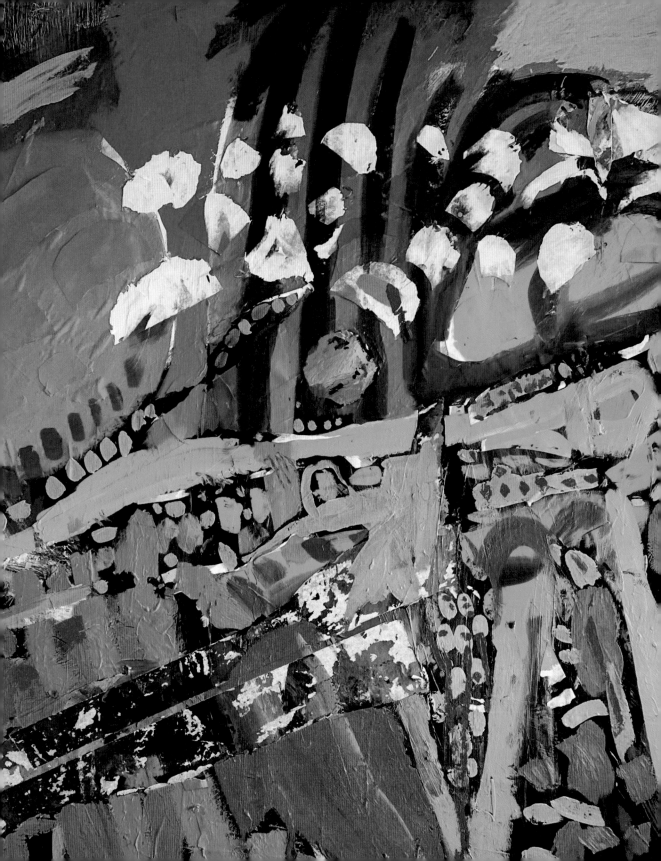

10. Stronger together

*'Alone we can do so little,
together we can do so much.'*

- Helen Keller

Sharing the creative experience

Let's get one thing straight: we are all *stronger* when we work *together*.

Having meaningful connections with others intensifies the colours of our life, enhancing our opportunities and experiences. Connection makes everything feel less daunting; you can laugh about the hard bits and celebrate the positives. Together. This chapter introduces you to what we mean by 'connection' and how this might be of benefit in your creative practice. We provide ideas for where to find your own creative connections and suggestions for activities to try together. Our artist is the fascinating Lubaina Himid and Emily's reaction is not to be ignored! At the end of the chapter, our task challenges you to get out into the real or virtual world and start building your own creative community so you can truly experience the joy of creative connection. We promise you will be stronger together!

PREVIOUS PAGE: The Town From Above, *Emily Powell, 2021, 200 x 200 cm, mixed media on canvas*
OPPOSITE: Sarah and Emily on Sarah's birthday, 2021.

'Anything is possible when you have the right people there to support you.'
- Misty Copeland

The *energy* **between us**

We find it's much more fun when we make art, talk about art, look at art and generally do all art-related things with other people who love it as much as we do! It might not be immediately apparent where to find your creative community, but believe us they are out there waiting for you.

Connection is a word with many different meanings, so let's be clear what we are talking about in this chapter. We love this explanation by Brené Brown: 'Connection is the energy that exists between people when they feel seen, heard and valued; when they can give and receive without judgement; and when they derive sustenance and strength from the relationship.'

This is the finest sort of friendship, a relationship to be nurtured and treasured. Building this sense of connection won't happen overnight but it is absolutely possible and totally worth the effort. Just make sure that you invest in people that are good for you; connecting should leave you feeling nourished and full of positive energy. The benefits of this sort of connection cannot be overstated. It can improve your quality of life, boost your physical and mental health and even help you live longer!

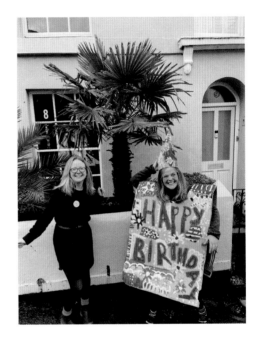

Emily – Don't feel like you have to find your people straight away; it's taken me years to build a trusted group that I can run things past and talk to about challenges. Slow and steady is definitely a good way to approach this.

Creative connection

So, we've convinced you that connection is a good thing, but how does it apply to painting? Just like the rest of your life, your painting life will be a richer experience as a result of truly connecting with others. That goes for everybody (*cough* introverts). No matter how much you enjoy spending time alone, art can be a lonely activity if you don't keep connected. We find sharing the creative experience with others gives us a real boost in energy and inspiration. It helps us generate ideas to take back to our own practice and expands our horizons to encompass the knowledge and experience of others.

Having people that you connect with is also really important for helping to critique your paintings, learning what does and doesn't work. This can be an experience that makes you feel very vulnerable, so try to share with people you trust and who do not make you feel judged. If you can do this then we promise you will learn so much from the experience. You can read more on this in chapter eleven, where we will provide you with the tools to give and receive criticism in a constructive way.

Emily – There is no need to be competitive in art. That's right. No need to be competitive. It's one of the reasons I love it so much. My best creative relationships involve a great deal of sharing, whether that be time, knowledge, materials or lots of laughter! Everyone has their fortes and we only become stronger when we work together.

Sarah – When I did an art course at the local college for a year, I really enjoyed working alongside other creative people. My core group consisted of four strong, inspiring women of different ages. We each brought our own unique ideas and life experiences to the table and could set each other off on different avenues of exploration. When times were tough, we were there to pick each other up and keep each other going. We shared laughter and tears and were vulnerable with each other in a way I'd never experienced before. At the end of the year, we were all stronger and braver than we knew possible, we had produced work that amazed our tutors, but best of all we had had a wonderful group of creative companions.

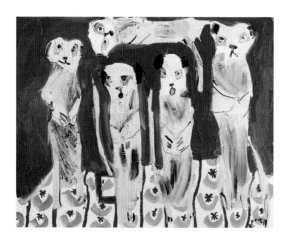

LEFT: The Meerkat Band, *Emily Powell, 2021, 100 x 120 cm, mixed media on canvas*
OPPOSITE: Detail of Triptych: New Place, *Emily Powell, 2019, acrylic on wood*

Finding creative *connections*

No matter how you prefer to interact, believe us when we say there are like-minded people out there waiting to meet you! Try:

- Art groups

- Urban sketchers

- Adult education courses

- Life drawing classes

- Events at local galleries

- Workshops

- Instagram

- Online communities

Try these with your creative companions

- Set a regular meeting date, such as the first Friday of each month, when you know you can come together and connect through your art.

- Take turns leading workshops to drag each other out of your comfort zones – remember you'll be much braver if you're having fun.

- Plan days out for each other – go to a gallery or location that is new to the other person and open their horizons. You'll see it through new eyes too.

If you're geographically separate, there's no excuse! Arrange a time where you can draw or paint and chat together regularly online – you can expand this to include workshops for each other and even visit places and museum collections online!

'The success of every woman should be the inspiration to another. We should raise each other up.'

- Serena Williams

Little Paris Group

When World War II broke out, Loïs Mailou Jones was abroad in Paris, enjoying the more liberal attitudes to race and the intense artistic milieu of the famous city. Back in her native USA, in Washington, D.C., in the 1940s, Lois missed the Parisian 'salons' where artists would come together to exchange knowledge and ideas and comment on each other's work. Never one to be stopped from doing what she felt important for her painting, Loïs decided to set up her own version of the salon, calling it the 'Little Paris Group'. In this artistic setting, many subsequently famous artists, such as Alma Thomas, were able to meet, learn and share ideas without experiencing the prejudice they were exposed to in other sections of American society at the time.

ABOVE: Little Paris Group *in Loïs Jones' studio, 1948*
BELOW: *Sarah leading a workshop*

Find your support network

Creative friends are great for motivating you when you're going through a slow patch, picking you up when things are difficult and of course sharing the good times! They understand the path you are on and can provide you with the support and encouragement needed to keep going. While it's great to celebrate success with friends, it is even more important to us to be able to laugh about all the 'failures'. It's much better to be able to say 'Here we go again, the Royal Academy rejected me, I wonder what it was this year?!' rather than internalise the feeling and take it to heart.

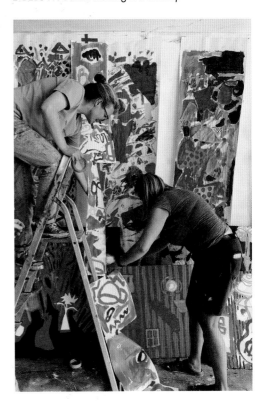

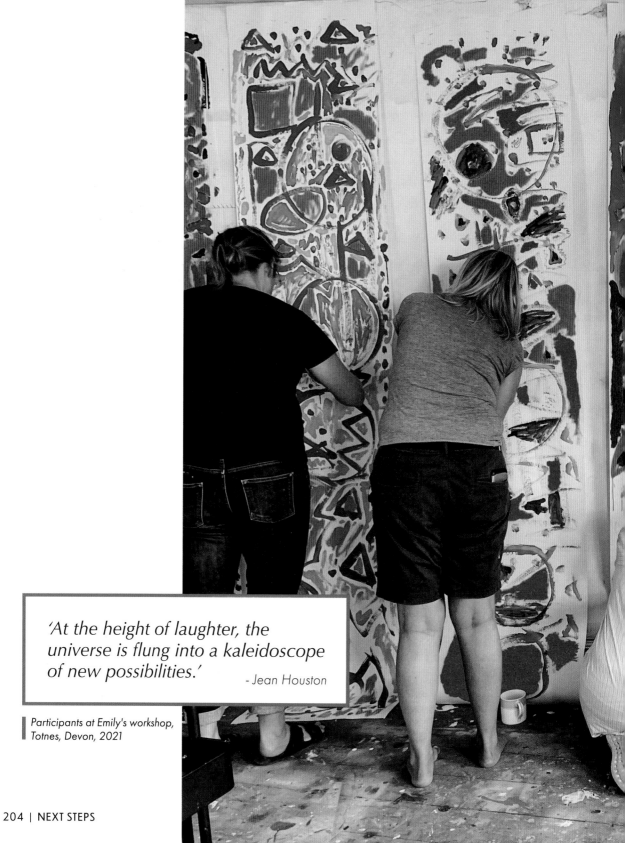

'At the height of laughter, the universe is flung into a kaleidoscope of new possibilities.'

- Jean Houston

Participants at Emily's workshop, Totnes, Devon, 2021

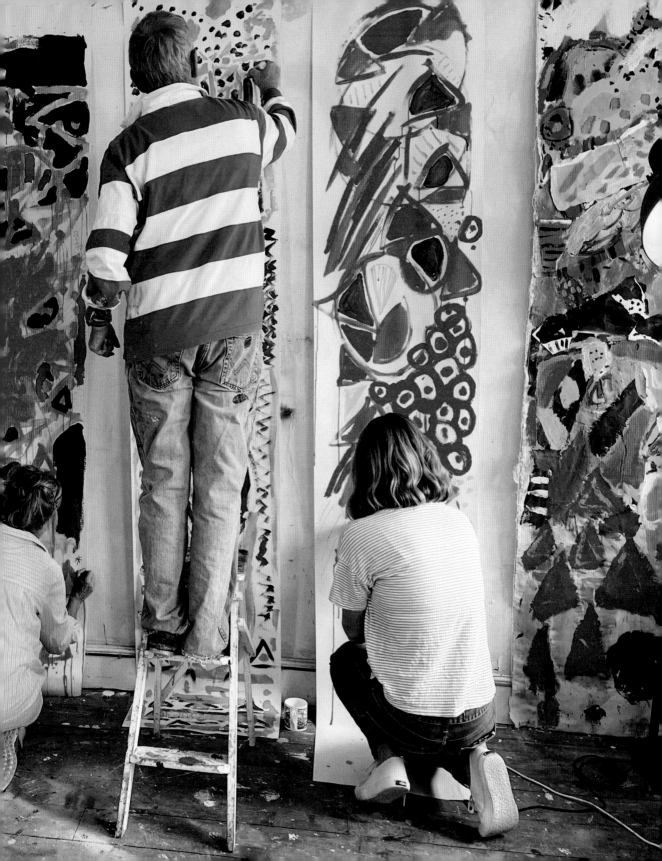

Lubaina Himid
1954–

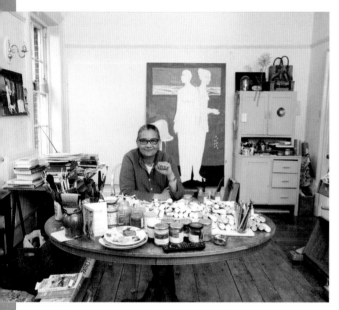

ABOVE: Lubaina Himid in her studio, 2017
OPPOSITE: Naming the Money, Lubaina Himid, 2004,
100 cut-out figures: plywood, acrylic, mixed media and
audio. Installation view, Navigation Charts, Spike Island,
Bristol, 2017

The bright colours and patterns of kangas, her training in theatre design and her passion for making the invisible visible are key to Lubaina Himid's artistic practice. These attributes have led to many personal successes, including being the first black female artist to win the Turner Prize in 2017. Beyond this, though, Lubaina's work is about creating a dialogue with the viewer, challenging their beliefs and assumptions and telling an alternate history through her art. *Naming the Money* was one such exhibit where Lubaina turned art history on its head. The cut-out figures have their own stories, giving voice to the experience of those who might otherwise be written out of history.

After completing an MA in cultural history at the Royal College of Art, Lubaina organised art shows that championed artists who might otherwise be marginalised. These exhibitions showed other young people the power of art. Lubaina has always been a teacher as well as an artist. As Professor of Contemporary Art at the University of Central Lancashire she enjoys a two-way exchange of ideas, always learning from her students. Alongside her teaching, Lubaina runs the 'Making Histories Visible' project, which is 'an exploration of the contribution of black visual art to the cultural landscape'.

'Belonging is not about geographical place [it is about] particular friends, mostly women, mostly artists with whom I belong.'

- Lubaina Himid

What can we *learn* from Lubaina?

1. Art is a fantastic vehicle for social change. It can be used to highlight important cultural and political issues in ways that engage the viewer and challenge their assumptions.

2. Breaking away from the traditional paint on canvas on a wall is a liberating experience that will challenge and excite both you and your audience. These are paintings that can't be ignored!

3. You can be a successful artist in your own right while championing the voices of others within your community. Reach out to others and help them to make their voices heard. Together you will be stronger.

Emily's reaction to Lubaina Himid

I love the colour and energy of Lubaina Himid's work and I feel her purpose of making the invisible visible is so incredibly important. Everyone deserves to be seen and not everyone feels seen; art is the perfect vehicle to change this. You can say exactly what you need to say, leave your apologies at the door. Stand up, hold your head up high and get that paintbrush out.

Lubaina really gives you the feeling of, OK, great I'm not going to just paint on paper and canvas I'm going to make my paintings 3D. What an empowering body of work to follow: it led me to ask my husband Jack to make me some huge wooden tigers to paint for an exhibition in Cornwall. We hadn't collaborated on a project like this before and we enjoyed it so much and are both so proud of the achievement. These are paintings that have been made together and brought art to people who might not visit traditional gallery spaces. These tigers will not be ignored!

'All my work is saying: let's put this on the table, communicate, negotiate, see what is the same about us, glory in the differences.'
— Lubaina Himid

OPPOSITE: Work in progress in the studio. Tigers of Tremenheere, Emily and Jack Powell, 2021, 300 cm high, acrylic on wood

#startpaintingnow

Building a network of creatives with the same ethos as you is a great way to develop new connections on social media. This task takes you through the process of becoming a key part of our #startpaintingnow community online and explores ways to maximise your interactions and develop your own creative network.

1. Chances are you already have a social media account such as Instagram, but if not then download the app or get on the website and get yourself set up.

2. Take a photo of one of the paintings you've done as a result of one of the tasks in an earlier chapter.

3. Post the photo and tag it with #startpaintingnow.

4. Search the tag #startpaintingnow and start following it, this way when other people who've read this book and chosen to post their work use the tag you'll see it in your feed.

YOU CAN'T USE UP
CREATIVITY
THE MORE YOU USE
THE MORE YOU HAVE
– MAYA ANGELOU

More, more, more!

We've found the more you put into this type of networking, the more you get out of it. One way to get into the habit of making the most of your social network is to get involved regularly. We recommend picking one day a week and, on that day, post something with #startpaintingnow, follow one new person whose work you find interesting and make a positive comment on one of the other posts tagged #startpaintingnow. You'll be amazed how quickly you build up a network of peers who are also finding joy in the creative process!

OPPOSITE: You Can't Use Up Creativity, *Sarah Moore, 2021, 30 x 42 cm, gouache on paper*

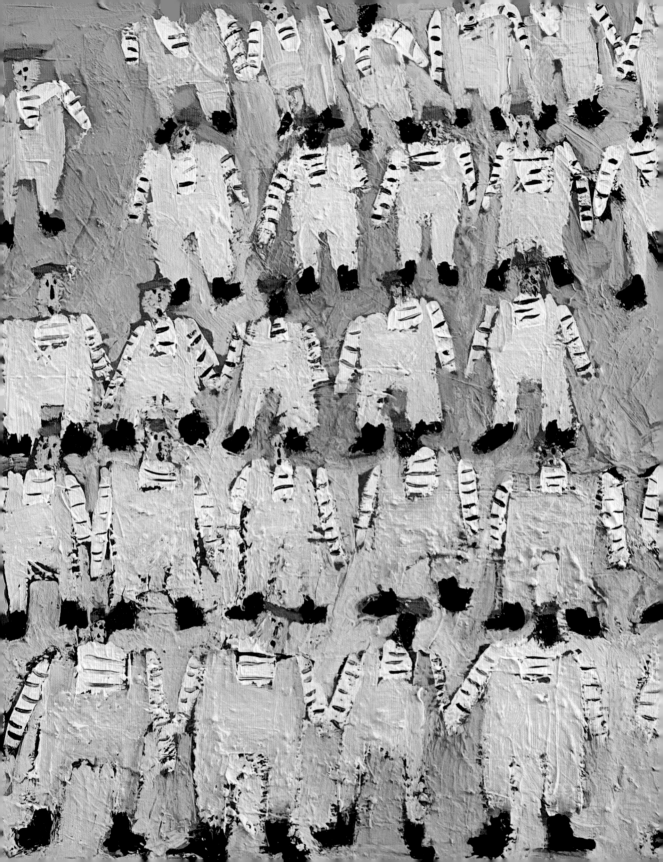

11. On display

'One of the things we couldn't do was go into museums, let alone think of hanging our pictures there. My, times have changed. Just look at me now.'

- Alma Thomas

Fly your flag

Shout it from the rooftops!
Be *proud* of your art!

Whatever stage you are at in your artistic journey, showing your work to others can be a fantastic way to boost your confidence and broaden your horizons. Whether your pictures are taped to the wall of your living space or hung at the Tate, you can learn a huge amount from the process of putting your work on display. This chapter takes you through the ways you can learn from displaying your paintings and gives you ideas for how to show your work. We explain the importance of taking pride in your art and introduce the idea of art *crittercism* as a constructive learning experience. Our artist is the legendary Georgia O'Keeffe and Emily reacts with a whole new perspective. Finally, it is over to you with our task: it's time to make an exhibition!

> *'We would sift through every inch of what it was that worked, or if it didn't, and wonder what was effective in it, in terms of paint, the subject matter, the size, the drawing.'*
>
> - Helen Frankenthaler

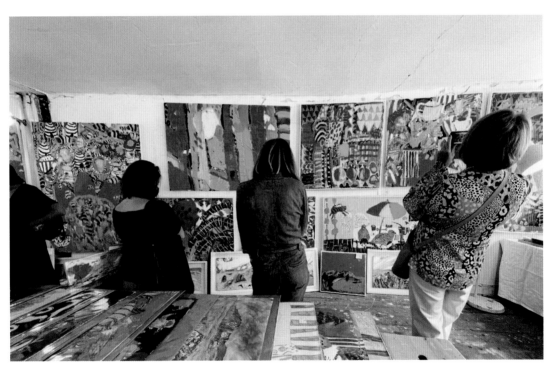

PREVIOUS PAGE: Fishermen, Emily Powell, 2021, 100 x 100 cm, oil on canvas
ABOVE: Emily's open studio in Totnes, September 2021

Why *exhibit* your work?

Exhilarated. Vulnerable. Liberated. Terrified. Energised. Inspired. We could go on all day with words that describe how it feels to put your work on display but, ultimately, we want you to know that this rollercoaster of clashing emotions is absolutely worth it. Showing your art acts as a one-stop shop to learning a huge amount about not only your work but also yourself.

You might have got the idea by now that we think showing your work is a great idea! But why are we so passionate about it? In a nutshell, the whole process is a fantastic learning experience.

There are so many ways to learn from the process of putting your work on display. Before the exhibition even starts you have to think carefully about what you are showing and why. Who is your audience and what do you want to say to it? Do you want to show that art can be filled with joy or tell a particular story? You'll need to consider where the art will be hung (or displayed online), what will appear next to it and how it will look in context. This will teach you a lot about how your works sit together or what makes one particular painting stand out.

During the show you have a wonderful opportunity to seek feedback from your audience. The insights people give are often really interesting, making you think about your work in a way that you might not have interpreted it before. Try to be there, at least some of the time, when the show is on so that you can interact with your audience to get the most out of the experience.

You can also share your work online. It's not the same as a show in real life but it's a good starting point for interacting with an audience. Using social media is a great way to achieve this; have a look at the task on page 210 to get started and remember that you'll get the most out of it if you engage with your viewers.

We've both found that the buzz of creative energy from showing our work is so intense that we can't wait to get into the studio and build upon what we have learned. Have a look at our task on page 228 for a simple way to get started with showing your work. We can guarantee the high you get and the amount you learn will sustain your creativity for months!

Emily – I always learn so much by putting my work in different spaces; which colours go together, which environments make my work look good. I've discovered that I always need a range of sizes for an exhibition and also that a stand-out exhibition needs a range of colours, not just turquoise! An exhibition is one big picture of all your other pictures. It's art in itself. Enjoy it, practise it.

Sarah – When I was seven years old, I drew a pencil sketch of a fuchsia flower. I was really proud of that drawing and gave it to Dad, who made me sign and date it. He took it to the shop to be put into a special frame, which he hung on the wall. I was looking at this faded image recently and realised just how important this simple act of endorsement was to my confidence in my own artistic ability and sense of self-worth.

ABOVE: Sarah's worked taped to the studio wall
RIGHT: Sarah's framed drawing of a fuschia from when she was seven years old.

Showing off

There is nothing wrong with being proud of yourself and your work. Nothing at all. Being proud is not the same as being arrogant or overconfident and pride in your work does not make you vain or conceited. This pride is independent of traditional measures of success such as 'likes' on social media or feedback from viewers. It is about having a sense of self-worth that allows you to decide for yourself what you think of your work while being open to learning from others. Having confidence in yourself and your work is an incredibly important and empowering component of being an artist. Don't be afraid to be proud.

Emily – If you want to grow your art practice then you need to be proactive. Reach out to places you dream of exhibiting in. No one will come and knock on your door. I've had so many rejections but these are balanced by some super-excited replies, which make all the effort worth it. Enjoy the rejections, it means you've put yourself out there. If you never take a risk, you'll never get the reward.

Q. Where can I show my work?
A. *Anywhere!*

There are so many places you can show your work:

- **In your home** – put your latest paintings on the wall and invite your family/friends over.
- **A show with your local art group** – these group shows can be an easy way to get started.
- **Open studios** – a wonderful opportunity to interact with the public at large.
- **Commercial art galleries** – if you want to make a living from your art you'll need to start forming relationships with gallerists.
- **Websites** – make your own website to share your work consistently.
- **Social media** – get quick feedback and build up your creative connections.

Emily – I love to make exhibitions in my house and I have done since I was little. I stick up all my work in a room and charge people to come and see it. I always made tickets and posters and still do! However playful this might seem it is also a really powerful way to learn things about your work.

OPPOSITE: Clockwise from top left: Emily and her sketches; Emily's open studio; Signs at Emily's open studio; Emily exhibiting on her house; Emily's kitchen splashback

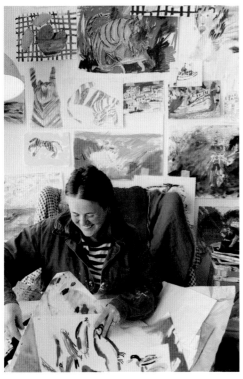

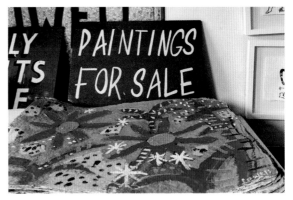

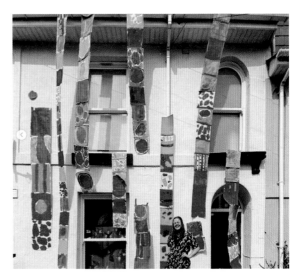

Crit*ter*cism

In normal everyday life criticism is a word with lots of negative connotations. We associate it with being told off or not meeting expectations. In the art world, however, criticism is not about finding flaws or mistakes, it is a process of analysis and evaluation. In the right context, this makes it a fantastic opportunity for learning.

Given the negative associations with criticism, we've switched it out and used crittercism instead. This always makes us smile and think of friendly critters looking at our work. But what are these critters going to say to make their contribution meaningful and constructive? We need to better understand this in order to get the most from both sides – as giver and receiver – of crittercism.

Learning how to think critically is a really important skill for every artist. We find it really helpful not only for working out what to do on our own work but also for looking at each other's work and that of other artists. It helps us to identify what works and why and we can use what we learn going forward with our own artistic practice. We thoroughly recommend you start practising this skill as it will make you a better painter!

'Take criticism seriously, but not personally. If there is truth or merit in the criticism, try to learn from it. Otherwise, let it roll right off you.'

- Hillary Clinton

OUR PERSONAL EXPERIENCES OF SHOWING OUR ART

Emily - The scariest experiences often turn out to be the best. Each time I've stepped outside my comfort zone, exhibiting in larger or more prestigious places, the fear has been absolutely worth it. It's part of the joy of being an artist, constantly testing yourself and pushing yourself further. Step up and be proud of yourself.

Sarah - I never thought I'd be particularly comfortable showing my art or feel a need to do so but I was inspired by Emily to join an Open Studio event one year. This was a wonderful opportunity to see how people interacted with my work and to hear live feedback from my audience – people even bought my art! It wasn't about the money, it was the principle of the thing. Somebody wanted my creation enough to buy it, take it home and put it up in their house. This made me really proud. It also gave me impetus (and funding) to do more painting!

OPPOSITE: Detail from Wild Flowers I Know, Emily Powell, 2019, 100 x 100 cm, oil on wood

Our top tips for getting started
with crit*ter*cism

1. Start by looking at the painting carefully, considering questions such as:

 a. What do you like about the painting?

 b. How does it make you feel?

 c. What story do you think it tells?

 d. Does the mark making or use of colour enhance the work?

2. For each of these questions think 'Why?' Simply describing what you see won't help you learn. By analyzing your thoughts and reactions you will gain a lot more from the experience.

3. If you're giving feedback, consider whether you have any ideas for things to try. Don't be afraid to make suggestions. These are usually best framed as 'how about . . . ?' or 'what would happen if you . . . ?' rather than 'you should . . .' so the recipient doesn't feel you are telling them what to do.

4. If you're the receiver rather than the giver of crittercism, make sure you ask those giving the feedback to tell you why they are saying specific things. Take on board what they say and make sure you think it through but don't feel like you have to agree.

Georgia O'Keeffe

1887–1986

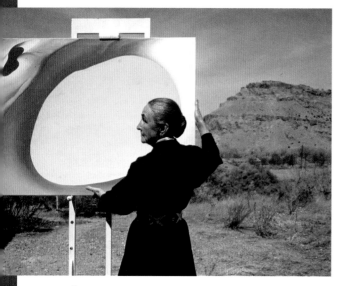

ABOVE: Georgia O'Keeffe adjusting a canvas from her Pelvis Series- Red With Yellow, Albuquerque, New Mexico, 1960
OPPOSITE: Ram's Head, White Hollyhock-Hills (Ram's Head and White Hollyhock, New Mexico), Georgia O'Keeffe, 1935, 76.2 x 91.4 cm, oil on canvas

'I found that I could say things with color and shapes that I couldn't say in any other way – things I had no words for.'

- Georgia O'Keeffe

In 1946 the Museum of Modern Art in New York put on its first ever retrospective for a female artist. That artist was Georgia O'Keeffe. Georgia discovered abstraction early and spent many months experimenting, developing her own language of shape and form. She mailed some of this work to a gallerist in New York who included the pieces in a show, and her practice grew from there. With the patronage of a gallerist, her work became increasingly well known, eventually expanding beyond his reach and defining her artistic practice in its own right.

Georgia's compositions are masterful, the result of many hours of hard work and a willingness to see the world in a different way. Her flower paintings are huge, presenting the blooms on a scale that could not be ignored. She used bones to frame the desert skies and aligned skyscrapers to point to the moon. When she moved to the desert and couldn't find flowers, she collected bones and painted them instead. She would drive out into the desert and paint all day, wedging her canvas into the back of the car and closing the windows to avoid the insects. Georgia was absolutely committed to her art and with her prolific output and her desire to get her work seen, she quite rightly became a legend in her own time.

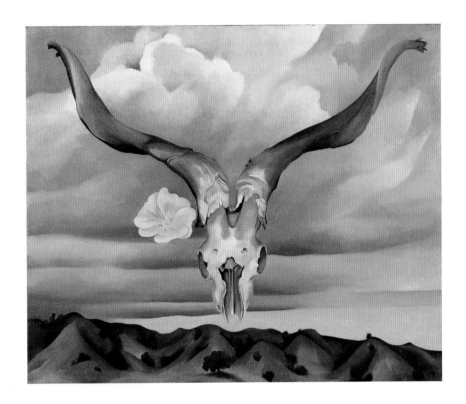

What can we _learn_ from Georgia?

1. Have a good solid look at your work and decide what you feel about it. Once you've done this then you can listen to other people's opinions, but remember to interpret them in light of what you've already worked out.

2. Don't be afraid to reach out to galleries. Only you can initiate the process of getting your work seen, nobody will come looking for you. Lose your fear of rejection and have a go!

3. Mentoring other artists is a wonderful way to learn and grow. Georgia corresponded with many other artists including Yayoi Kusama, who credits her for the encouragement she needed to make the leap from Japan to New York.

Emily's reaction to Georgia O'Keeffe

Georgia O'Keeffe's work is unapologetic and I find that totally inspiring. I love that she took a different view of objects that surround us every day, playing with perspective and composition. Georgia developed her own style that is incredibly distinctive and engaging, while constantly evolving her practice. She worked really hard at her art, showing the discipline required to keep learning. No wonder artists like Yayoi Kusama found her so inspirational.

This is the piece I created in reaction to Georgia's work. It's a different perspective on the traditional form of the beach windbreak. It was such an interesting exercise to play with the scale of the object, blowing it right up until there was no way you could ignore it! I had the courage to walk away from the work earlier than usual and really enjoyed the process. It's bold and strong and feels very empowered. Thanks Georgia, you legend.

RIGHT: Beach Wind Break, *Emily Powell, 2020,*
100 x 300 cm, mixed media on canvas

'I get out my work and have a show for myself before I have it publicly. I make up my own mind about it – how good or bad or indifferent it is. After that the critics can write what they please.'

- Georgia O'Keeffe

Exhibition time

You might have read this chapter and thought 'nice to know but I won't be doing this'. Well, tough luck – you are! In this task you'll be putting on your first exhibition . . .

1. Have a look back at all the work you've produced so far while reading this book and doing the tasks and pick what's going to be in your show.

2. Have a little think and write down a couple of lines on how you feel about each piece.

3. Work out how you will display your pieces – paper can be taped to a wall or use a frame to make it look professional. Canvases and boards can be hung on walls or leant up on easels, furniture or worktops.

4. Design a poster for your exhibition with your name and the date of your exhibition. Bonus points for a great exhibition title!

5. Invite your family or friends to see the show. Make them dress up for the occasion and open a bottle of wine or provide tea and cake. The crucial thing here is that you invite people who are supportive!

6. Make the most of the opportunity to see people interact with your work, find out what they like and why.

7. Rest and relax – exhibitions are tiring!

8. When you've rested and have had some time to process the exhibition, go back to your notes from before and compare them – see what difference the exhibition has made and use all of the ideas and momentum you've generated to plan your next paintings!

ABOVE: Emily's open studio poster, 2021

More, more, more!

Get together with another artist or group of artists and organise a show. It might be you and your children and you put on the show for the family in the living room or you might want to take over an empty shop and do a pop-up with your art group. However you do it, we promise you'll find enormous pleasure and energy from the sharing of the experience.

ABOVE: Sarah's exhibition poster, 2021

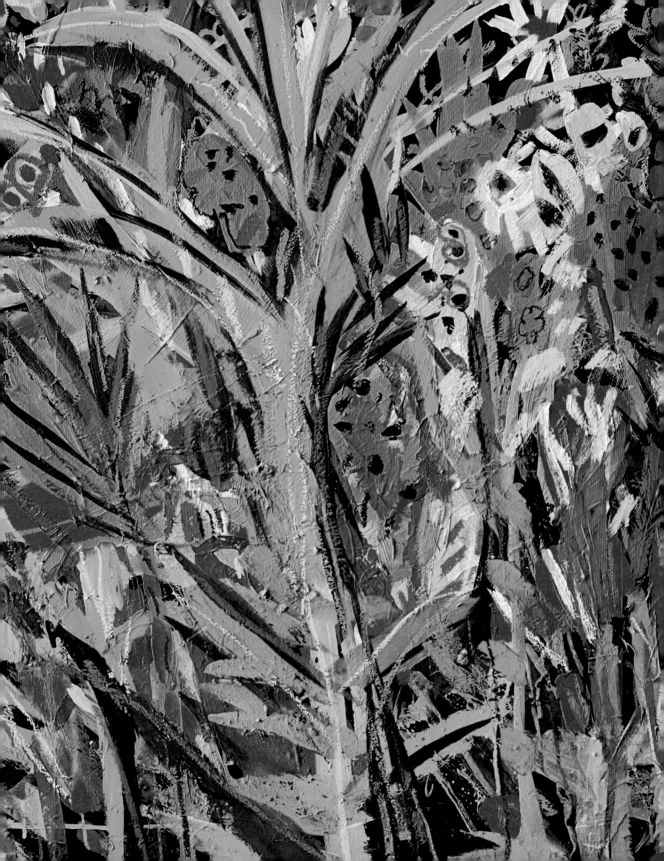

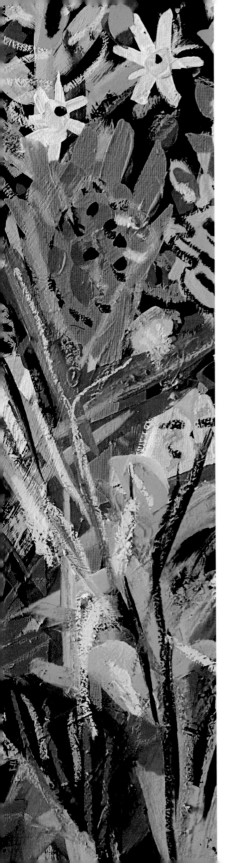

12. Not giving up

'Just don't give up trying to do what you really want to do. Where there is love and inspiration, I don't think you can go wrong.'

- Ella Fitzgerald

Never give up

We really want you to feel like you have the tools to keep on painting. Sure, have a rest, have a holiday, go and gather inspiration, but . . .

NEVER

EVER

GIVE

UP!

Those who get the most out of painting push through the hiccups they encounter along the way, pick themselves up when they get rejected and understand how to learn from criticism. This chapter puts the finishing touches on learning to be a resilient artist who can weather negativity and self-doubt and keep going even when it feels difficult. We start by taking a look at how to keep your creative fire burning and explore the importance of not attaching your own self-worth to your work. We explain how to set SMART goals and share with you some of our own. Next, we introduce you to our fabulous artist Etel Adnan, whose paintings and creative expression take many forms, and Emily gets very excited by Etel's strong sense of self and her persistence in pursuing her art. Finally, it's over to you for your last task, making your own book of fire to help you to never, ever give up.

'Courage doesn't always roar. Sometimes it's the quiet voice at the end of the day whispering, "I will try again tomorrow."'

- Mary Anne Radmacher

Never *ever* give up

Just in case you hadn't got the message yet, we have only one golden rule about painting: **NEVER EVER GIVE UP.**

Achieving this requires dedication and sacrifice but it is absolutely possible. Keep that strong sense of self, protect your creative fire, don't let it go out. Sure, negative things will come along and the fire will die down a bit, but stick another inspiration log on and Just. Keep. Going. We've already given you a lot of the tools to keep your creative fire burning, including looking after yourself (chapter two), banishing excuses (chapter four), and keeping yourself inspired (chapter five). In this chapter we want to introduce you to a few more ideas to help you in your mission to NEVER EVER GIVE UP.

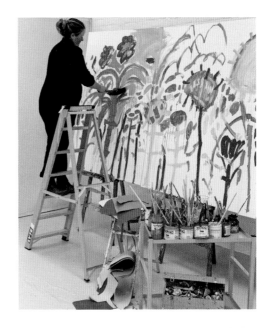

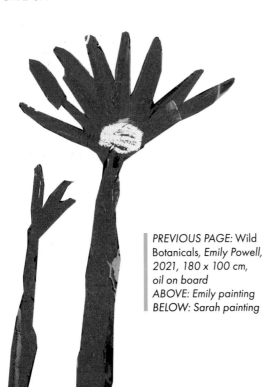

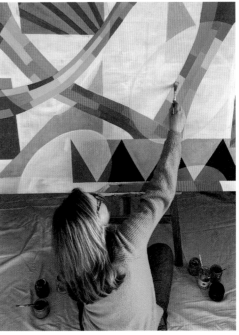

PREVIOUS PAGE: Wild Botanicals, *Emily Powell, 2021, 180 x 100 cm, oil on board*
ABOVE: Emily painting
BELOW: Sarah painting

Stoking your creative *fire*

Nothing in life is ever straightforward, but if it was we'd probably never learn anything! The key thing is that we are able to recognise the stumbling blocks for what they are and work out strategies for getting around them. If you want to make sure that you don't give up then you need to build robust mechanisms for picking yourself back up when you hit these stumbling blocks.

One great way we've found for picking ourselves up is to very consciously do more of what matters to us. When we stop doing the things that are important to us we can end up in a cycle of negative thoughts and feelings, but if we push ourselves to start doing what matters to us again, we can boost ourselves out of this negative circle and into feeling positive about our art once more. Just think of the activities that matter to you as the logs you need to get your creative fire burning bright!

If you want to read more about this idea, look up Behavioural Activation Theory, on which it is (loosely!) based.

Log pile

talk to a friend

try something new

break the rules

look after yourself

get inspired

have a go!

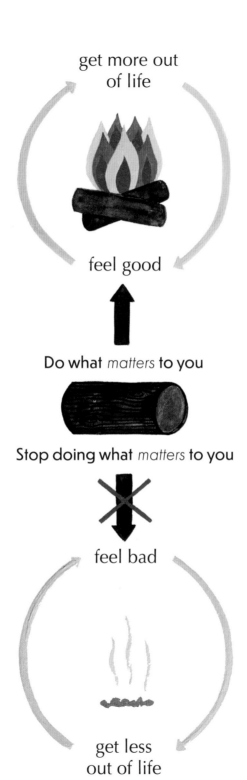

get more out
of life

feel good

Do what *matters* **to you**

Stop doing what *matters* **to you**

feel bad

get less
out of life

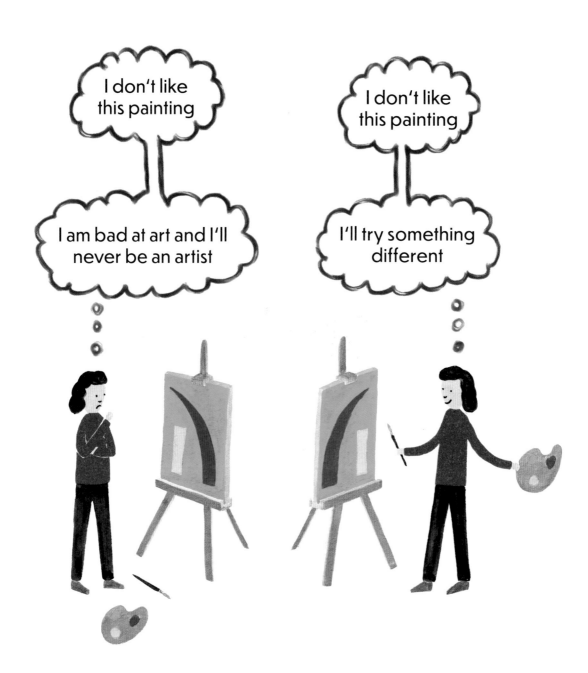

You are *not* your art

It is also super important that you keep your sense of self-worth detached from the art that you make. We have to do this so that we can put our art out there in the world and say 'this is my work', then if it doesn't get the response we want, we don't think 'my painting is terrible' therefore 'I am terrible at art'. Your artwork is extremely personal, so it is easy to start falling into this trap. We've both been down this path and it never ends well!

By stepping back and saying 'OK, well that person didn't like my painting but I do and that's what matters', or 'I'm not happy with that painting, so what can I do to change it?' you will suddenly open up a whole world of new possibilities. The alternative is that you decide you are terrible at art and you'll never paint again, leading to retreating back into yourself and (whisper it) giving up. If that happens to you, it *is* possible to get going again, but it does take a big effort. We've learnt it's best to try to avoid giving up in the first place!

'If you're one of those people who has that little voice in the back of her mind saying, 'maybe I could do [fill in the blank],' don't tell it to be quiet. Give it a little room to grow, and try to find an environment to grow in.'

- Reese Witherspoon

We want everybody to reach for the stars. Aim high and never be embarrassed about your dreams.

REACH FOR THE STARS

Emily – I'd love to be a Royal Academician.

Sarah – I'd love to write and illustrate a children's book.

Over to you – What's your secret ambition?

It's great to have long-term super goals like this but how do we make them a reality? And what do we do in the short term? Luckily, there are some great strategies to help you reach these goals. Let's take a look on the next page.

Setting goals *smartly*

We don't know about you but we often find ourselves thinking 'Well, nobody is going to know if I don't paint a picture/email a gallery/put on an exhibition'. By not holding ourselves accountable we are easily able to slip back into making excuses (for more on this revisit chapter four). One of the best ways to hold yourself accountable and ultimately to stop you giving up is to set out your goals.

Setting goals is all well and good but they are much more useful if you give them a bit of thought or you might end up with unachievable goals with no clear time frame that are discouraging and stressful rather than motivating and enjoyable. One of the most commonly used (and useful) ways to set your targets is by using the SMART goals framework.

Once you've set your goals, how can you motivate yourself to achieve them? Some of us have high intrinsic motivation, but we don't all have this – and none of us has it all the time. This is the point where writing your goals down and sticking them in a place you can see them daily comes into its own. There's no ignoring your goals if you do this. Taking it one step further you can tell a friend what you plan to do – this extra level of accountability can be really helpful for boosting your motivation when you are struggling and thinking you might give up.

If you get really into goal setting you can even split them into short and long term. Here are a couple of examples of short-term SMART goals:

OPPOSITE: *Detail from* Collage Park by My House, *Emily Powell, 2020, 100 x 100 cm, mixed media on canvas*

Sarah – I'm going to join in with one online art class in the next week and post one of the drawings I do on Instagram straight after the class.

Emily – I'm going to do three watercolour paintings of my teapot collection and send my favourite one to the framers in the next five days.

'We ask ourselves, Who am I to be brilliant, gorgeous, talented, fabulous? Actually, who are you not *to be?'*

- Marianne Williamson

Specific	Who? What? Where?
Measurable	How will you know you've completed it?
Achievable	Is this a realistic goal?
Relevant	How does it fit into your journey?
Time-bound	What is the deadline?

Once you've completed your goal, don't forget to **CELEBRATE!** We like to plan what we will reward ourselves with. This definitely gives us extra motivation, and allows us time to look back and appreciate what we have achieved. Painting for half an hour might get us a cup of tea and a biscuit, while signing a book deal might be rewarded with a posh afternoon tea!

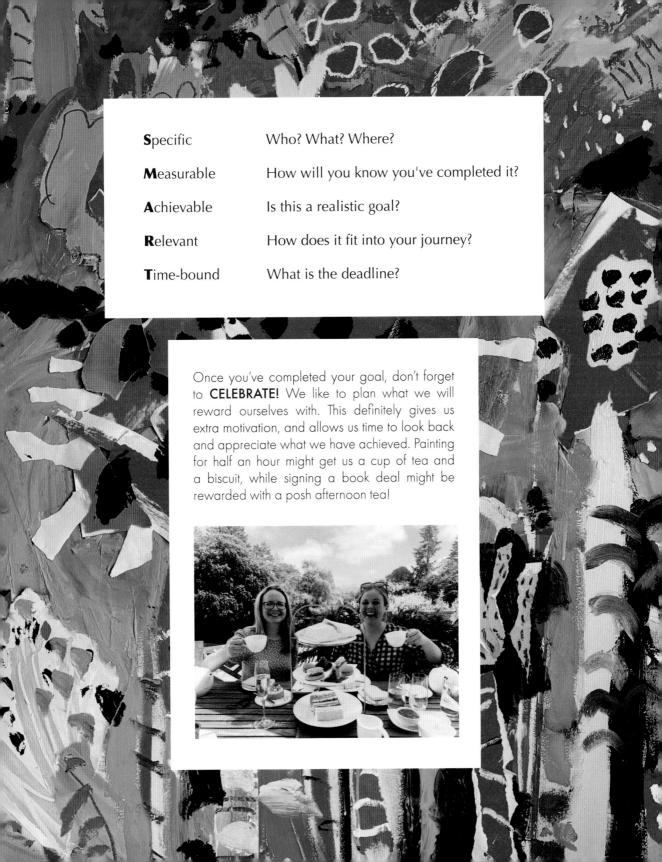

Etel Adnan
1925–2021

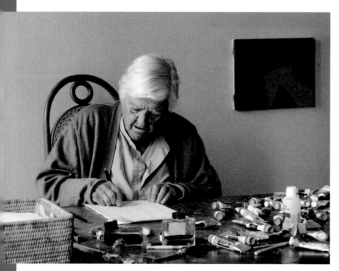

ABOVE: Etel Adnan at work in her Paris studio, 2016
OPPOSITE: Mount Tamalpais, Etel Adnan, 1985,
148 x 125 cm, oil on canvas

Having started painting at the age of thirty-four, Etel didn't stop. When she began, Etel would draw or paint a red square on the canvas and work outwards, instinctively feeling her way through the colours and shapes, learning all the time. Through this experimentation she developed a distinctive style. Etel only used a palette knife, which allowed her to lay down thick paint decisively in vibrant colours, making definite marks that would not be fiddled with later. Her paintings are very personal and very much an expression of what it is to be Etel.

Although born in Lebanon, educated in Paris and having lived in America and travelled widely, Etel returned repeatedly to California's Mount Tamalpais in her paintings. Even when she was physically distant, it provided endless fascination and inspiration and she never gave up her exploration of the mountain. Not only did Etel paint it thousands of times, she also wrote a book, contemplating art and nature in relation to the mountain. This is no surprise as Etel often used her philosophical training and love of the written word to tell her story. She mixed these with images in folded books called leporellos that contained poetry and observations alongside paintings and drawings. Whatever the medium, Etel never gave up expressing herself in her own way.

'My painting is very much a reflection of my immense love for the world, the happiness to just be, for nature, and the forces that shape a landscape.'

- Etel Adnan

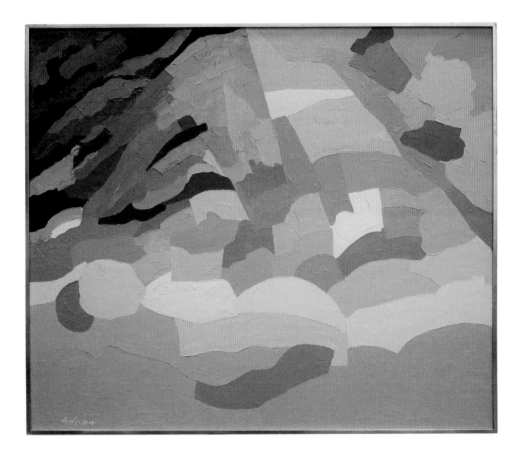

What can we *learn* from Etel?

1. It doesn't matter when you start painting, you can still have a wonderful artistic life if you keep going and stay true to who you are and what fascinates you.

2. You can be many things as well as a painter. As you keep on painting, these other passions will feed into your art and serve to enhance it.

3. There's no need to keep words and pictures separate. Words are symbols. For artists like Etel, the combination of these forms of expression is very important and can create powerful statements.

Emily's reaction to Etel Adnan

I love how Etel is unafraid to be herself and that she uses her paintings as a way to express this. She is bold and decisive in her use of colour and I get a very strong sense from her work that she backed herself fully. I feel like I can see her determination and the way she looked after her creativity. Those paintings didn't paint themselves; I think they must have taken a lot of serious chats with herself. And I love that. I'm so enthralled by people who are involved with and driven by their passion. Etel is a perfect example to us all. She seems to have always painted for herself and didn't listen to the haters, or maybe she did, but it looks like she had a good cuppa and carried on anyway!

The freedom to do whatever you like – doesn't that just make you want to cry with happiness? Etel took her own path and that sense of liberation inspired this painting. I realise it's not everyone's cup of tea but I don't care! I painted what I wanted to paint and it gave me so much energy and joy.

'I write what I see; I paint what I am.'

- Etel Adnan

▍ *ABOVE:* Tigers of Perranporth, *Emily Powell, 2021, 120 x 150 cm, oil on canvas*

My book of fire

For your final task we want you to have a good hard think about what it is that's going to help you keep your painting fire burning . . . and then paint it in a concertina book! You can make these books as big or small as you like and carry them in your bag or put them on the mantelpiece. Whenever you're having a painting (or life!) wobble you can pick them up and have a look through at all the exciting things you'd like to achieve and how you might get there.

1. Make a concertina book – start by folding a piece of paper in half lengthways.

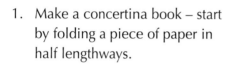 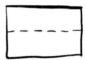 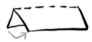

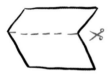

2. Cut along the fold line to create two strips.

3. Fold each section in half and fold the ends into the middle.

 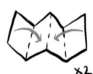

4. Glue or tape the first page of one half to the last page of the other to make a long folded strip.

5. Make a fiery title page – use wonderful warm colours and go abstract or spend some time really looking at a fire and paint how it makes you feel – then write yourself a title: My Book of Fire.

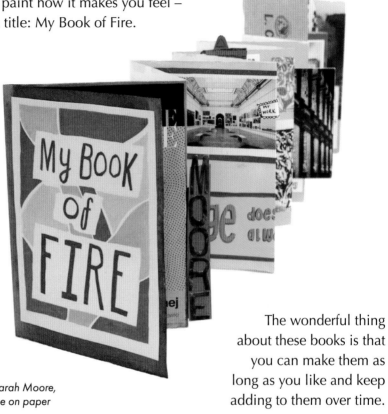

ABOVE: Sarah's task
BELOW: Emily's task
NEXT PAGE: Never Ever, Sarah Moore, 2022, 30 x 42 cm, gouache on paper

The wonderful thing about these books is that you can make them as long as you like and keep adding to them over time.

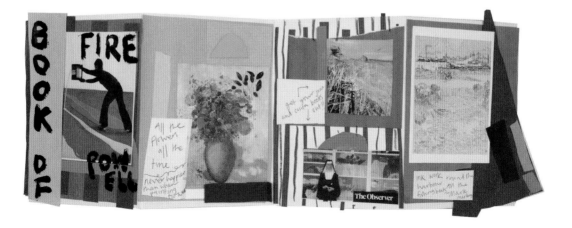

6. Time to get stuck in with the book itself and fill it with both things you want to achieve and things that you know will keep you going. Here are some ideas for what to paint on the first pages, but it's entirely up to you!:

- Who are your art heroes? Paint a picture of them or stick in their work and make notes about why they inspire you.

- What scenery have you always wanted to paint? Put in a trip you'd like to take or a landscape you'd like to get to know better.

- Where do you want to see your artwork hung? Don't be shy, put it on the walls of the Tate or MoMA alongside your heroes.

- If you could try anything in paint, what would it be? Maybe you'll draw a picture of the mural you want to paint on a building or a series of tiny watercolour portraits of bugs from your garden.

- Copy down the quote that motivates you most in big bold letters and decorate all around it in your favourite colours.

- Stick in a photo or do a painting of your friends or family or pets and make them into your painting cheerleaders.

- How do you recharge your batteries? Paint a picture of yourself in the bath or cycling up a mountain – whatever helps you to energise yourself.

More, more, more!

Now it's over to you. Keep adding things over time and don't be afraid to go back and change things as you develop. Remember, this is for you and nobody else . . . and don't forget the golden rule:

Quote references

Page 19. Faith Ringgold, from the film *Who I Am* (Read180 Videos, 2019).

Page 20. Judy Chicago, *Through the Flower: My struggle as a Woman Artist* (iUniverse, 2006).

Page 22. Loïs Mailou Jones, *The Art and Life of Loïs Mailou Jones*, Tritobia H Benjamin (Pomegranate Communications Inc, 1994).

Page 26. Oprah Winfrey, *What I Know for Sure* (Pan Macmillan, 2014).

Page 28. Emily Kame Kngwarreye quoted in the National Museum of Australia Symposium, 2008.

Page 37. Maya Angelou, from an interview in *Bell Telephone Magazine*, 1982.

Page 38. Brené Brown, from an article called 'How to Set Boundaries' for Oprah.com.
https://www.oprah.com/spirit/how-to-set-boundaries-brene-browns-advice#:~:text=Daring%20 to%20set%20boundaries%20is,can%20we%20 say%20%22Enough!%22

Page 43. Thema Bryant-Davis, *Tweets For The Soul: When Life Falls Apart* (Redeemed Media and Publishing, 2015).

Page 46. Agnes Martin, quoted in Agnes Martin, *Paintings, Writings, Remembrances*, Arne Glimcher (Phaidon, 2012); **Rose story:** from the film *Beauty is in Your Mind* (TateShots, 2015); **Pull-out quote:** Agnes Martin, 'Beauty is the Mystery of Life' *Agnes Martin: Writings – Schriften* (Hatje Cantz, 2005).

Page 48. Agnes Martin, *Agnes Martin: Writings – Schriften* (Hatje Cantz, 2005).

Page 55. Katharine Hepburn, American actress, 1907–2003.

Page 56. Helen Frankenthaler, from the film *OK to Print* (Kenneth Tyler Film and Sound Archive at the National Gallery of Australia, 1994).

Page 58. Julia Cameron, *The Artist's Way* (Pan Macmillan, 1993).

Page 77. Alice Neel, quoted *Alice Neel: The Paintings of Two Decades*, edited by Patricia Hill (Boston University Press, 1980).

Page 78. Emily Carr, Canadian artist and writer, 1871–1945.

Page 80. Amelia Earhart, American aviation pioneer, 1897–1939.

Page 82. Florence Nightingale, *The Life of Florence Nightingale*, by Sir Edward Cook (Edward Tyas Cook, 1913).

Page 88. Maud Lewis, quoted in the film *One of Canada's Great Artists: Maud Lewis* (CBC Archives, 1965).

Page 90. Ibid.

Page 95. Corita Kent, from the film *Introduction to Corita Kent and the Corita Art Center* (Corita Art Center, 2021).

Page 96. Agnes Martin, *Agnes Martin: Writings – Schriften* (Hatje Cantz, 2005)

Page 101. Georgia O'Keeffe, American painter, 1887–1986.

Page 102. Meryl Streep, American actor, 1949–.

Page 104. Fahrelnissa Zeid, as quoted in the article *Fahrelnissa Zeid: city by city* (Tate.org.uk, 2022).
https://www.tate.org.uk/art/artists/fahrelnissa-zeid-22764/city-by-city

Page 106. Fahrelnissa Zeid, as quoted in the article *Fahrelnissa Zeid in four key works* (Tate.org.uk, 2022).
https://www.tate.org.uk/art/artists/fahrelnissa-zeid-22764/four-key-works

Page 113. Elizabeth Broun, from an interview with *The New York Times* (2006).
https://www.nytimes.com/2006/06/27/arts/design/27smit.html

Page 114. Michelle Obama, *Becoming* (Viking, 2018).

Page 116. Brené Brown, *Rising Strong* (Vermilion, 2015).

Page 118. Brené Brown, *Daring Greatly* (Penguin Life, 2015).

Page 122. Faith Ringgold, *We Flew over the Bridge: The Memoirs of Faith Ringgold* (Duke University Press, 2005).

Page 124. Ibid.

Page 132. Brené Brown, *Daring Greatly* (Penguin Life, 2015).

Page 137. Georgia O'Keeffe, American painter, 1887–1986.

Page 138. Leonora Carrington, *The Seventh Horse and Other Tales* (Penguin, 1988).

Page 141. Elaine de Kooning, as quoted in *It Is* (No. 4, Autumn, 1959).
http://www.worldcat.org/oclc/79463183&referer=brief_results Magazine for Abstract Art, Second Half Publishing Co., New York

Page 144. Alice Neel, from an interview with Cindy Nemser (August 2, 1971, Getty Research Institute).

Page 146. Lee Krasner, *Three Artists (three Women): Modernism and the Art of Hesse, Krasner, and O'Keeffe*, edited by Anne Middleton Wagner (University of California Press, 1996).

Page 148. Lee Krasner, as quoted in *Lee Krasner: Living Colour*, edited by Eleanor Nairne (Thames & Hudson, 2019).

Page 154. Leonor Fini, as quoted in *Sphinx: The Life and Art of Leonor Fini*, Peter Webb (Vendrome Press, 2009).

Page 156. Virginia Woolf, *The Voyage Out* (Penguin, Revised Edition 1992).

Page 158. Paula Rego, as quoted in *Paula Rego*, edited by John McEwen (Phaidon, 1992).

Page 166. Elizabeth Blackadder, from the film *The Art of Elizabeth Blackadder* (Royal Academy APV Films, 2013).

Page 168. Elizabeth Blackadder, from the short film *Elizabeth Blackadder In the Studio* (National Galleries Scotland, 2011).

Page 173. Laura Ingalls Wilder, *Laura Ingalls Wilder's Prairie Wisdom*, edited by Yvonne Pope (Andrews McMeel Publishing, 2006).

Page 174. Etel Adnan, from an interview with Nana Asfour in *The Paris Review*, 2012. https://www.theparisreview.org/blog/2012/10/18/sea-and-fog-the-art-of-etel-adnan/

Page 177. Sylvia Plath, *The Bell Jar* (Faber & Faber, main edition 2005).

Page 184. Joan Eardley, from the short film *Joan Eardley, A Sense of Place* (National Galleries Scotland, 2016).

Page 186. Ibid.

Page 197. Helen Keller, American author and political activist, 1880–1968.

Page 198. Misty Copeland, American ballet dancer, 1982–.

Page 202. Serena Williams, from a speech at Glamour's Women of the Year Awards, 2015. https://www.glamour.com/story/best-advice-women-ever

Page 204. Dr Jean Houston, American author and philosopher, 1937–.

Page 206. Lubaina Himid, from the short film *I'm a Painter and a Cultural Activist*, (TateShots, 2018).

Page 208. Ibid.

Page 212. Maya Angelou, from an interview in *Bell Telephone Magazine*, 1982.

Page 214. Alma Thomas, as quoted in *Alma Thomas*, Thomas, A., Berry, I., & Haynes, L. (Prestel Publishing, 2016)

Page 216. Helen Frankenthaler, from the film *OK to Print* (Kenneth Tyler Film and Sound Archive at the National Gallery of Australia, 1994).

Page 224. Georgia O'Keeffe, American painter, 1887–1986

Page 226. Ibid.

Page 233. Ella Fitzgerald, American jazz singer, 1917–1996.

Page 234. Mary Anne Radmacher, writer and artist, 1957–.

Page 239. Reese Witherspoon, from an essay written for *Glamour* magazine, 2017. https://www.glamour.com/story/reese-witherspoon-october-2017-cover-interview

Page 240. Marianne Williamson, *A Return to Love* (Harper Thorsons, 2015).

Page 242. Etel Adnan, from an interview with Nana Asfour in *The Paris Review*, 2012. https://www.theparisreview.org/blog/2012/10/18/sea-and-fog-the-art-of-etel-adnan/

Page 244. Etel Adnan, as quoted in an article in *The Paris Review*, 2012. https://www.theparisreview.org/blog/2012/10/18/sea-and-fog-the-art-of-etel-adnan/

Picture credits

Index

Acknowledgements

Thank you first to Carole for believing in our vision and supporting our dream; we are so grateful for the fabulous team we've worked with at Bluebird who have guided us skilfully through the world of publishing.

To Izzi, our wonderfully talented designer, we want to say a huge thank you for all your creativity, energy and expertise. You were able to translate our ideas into reality and your patience and organisation made it a delight to work with you.

Huge love to baby Beatrix who arrived in a burst of joy halfway through the process and finally, this book would simply not have been possible without the tireless support of our husbands Jack and Tomasz; to you both we say thank you from the bottom of our hearts.